Paintings by NEW ENGLAND PROVINCIAL ARTISTS: *1775-1800*

T0204747

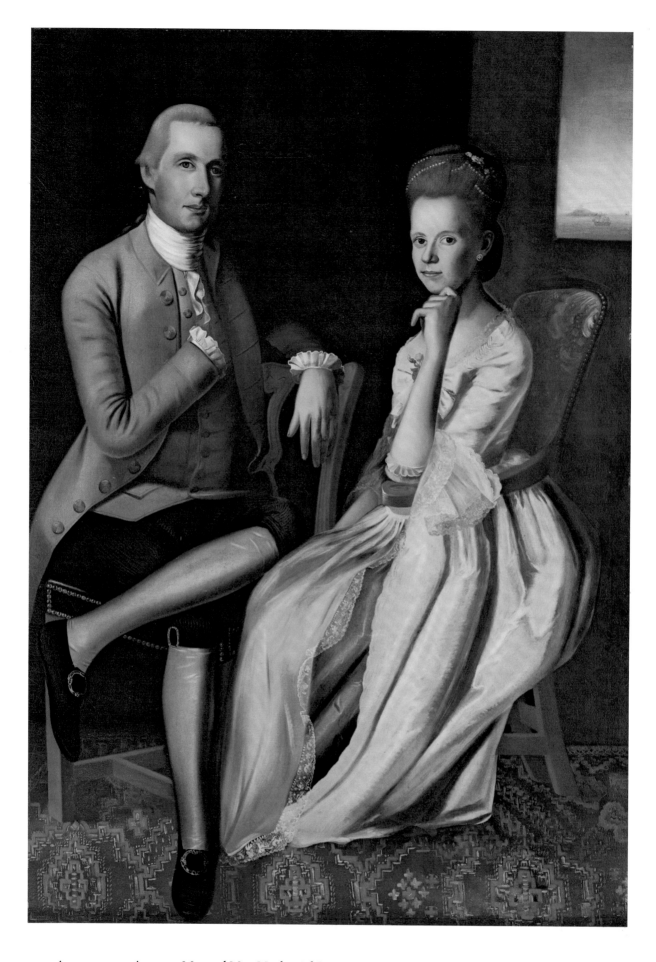

2 ANONYMOUS ARTIST. *Mr. and Mrs. Nathaniel Seaver, Jr.* (no. 7)

Paintings
by
New England
Provincial
Artists
1775-
1800

Exhibition and Catalogue by

NINA FLETCHER LITTLE

Museum of Fine Arts
Boston

Library of Congress Catalogue Card No. 76-21905 ISBN 0-87846-100-0

Type set by Dumar Typesetting, Dayton, Ohio Color separations by

Techno-colour Co., Inc., Montreal Printed by The Leether Press, Boston

Designed by Carl F. Zahn Exhibition dates: July 21-October 17, 1976

Foreword

Paintings by New England Provincial Artists, 1775-1800, brings to the Museum of Fine Arts a part of early American painting that in recent years has become better understood and more appreciated. Several previous exhibitions have shown the works of the individual artists represented here, painters whose expression differed from the fashionable tradition of European painting.

While charting the bicentennial program for the Museum of Fine Arts, it became apparent that although other museums were planning major exhibitions of folk and primitive art, a large and important group of provincial, professional painters of the Colonial and Federal periods might be overlooked. Therefore, we invited the one person we felt was best equipped to do justice to the provincial story, Mrs. Bertram K. Little, (better known to everyone in the American field through her extensive writings, collecting, and preservation efforts as Nina Fletcher Little) to organize an exhibition that would show the best work of these native painters. We are delighted that she accepted the challenge and are pleased to exhibit here the results of her efforts.

It seems appropriate in this bicentennial year to present also another aspect of Colonial and Federal painting. To contrast with and supplement the provincial paintings, the museum staff has mounted the exhibition "Copley, Stuart, West." These celebrated painters followed, and in some cases set fashionable academic trends abroad, whereas provincial artists like William Jennys and John Durand painted forthright, stark portraits without the subtleties of European style.

The paintings selected by Mrs. Little for this exhibition were originally done in New England and most have remained here in private homes and public collections. Some very important loans come to us, however, from Williamsburg, Virginia; Fort Worth, Texas; Philadelphia, and New York, to mention only a few. To all those persons and organizations who have shared with us their treasures, to Mrs. Little who has assembled an outstanding exhibition and has written an illuminating accompanying text, and to the staff of the Department of Paintings who helped mount the exhibition, I wish to extend the most sincere appreciation in behalf of the museum.

<div style="text-align: right">

JAN FONTEIN
Acting Director

</div>

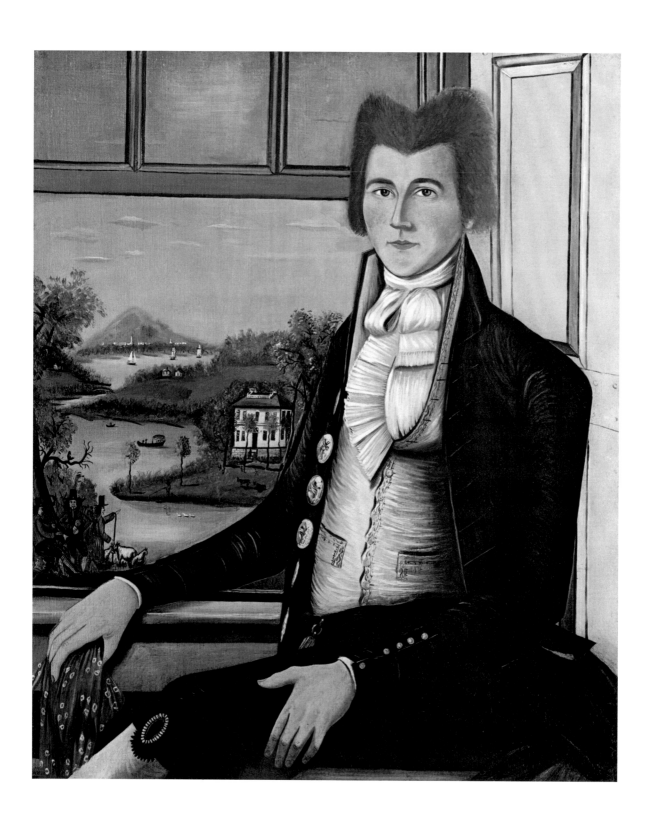

6 ANONYMOUS ARTIST. *Timothy Swan* (no. 12)

Lenders

ABBY ALDRICH ROCKEFELLER FOLK ART COLLECTION, *Williamsburg, Virginia*
ALBRIGHT-KNOX ART GALLERY, *Buffalo*
LYMAN ALLYN MUSEUM, *New London*
AMERICAN ANTIQUARIAN SOCIETY, *Worcester, Massachusetts*
BROOKLINE HISTORICAL SOCIETY
AMON CARTER MUSEUM, *Fort Worth*
THE CONNECTICUT HISTORICAL SOCIETY, *Hartford*
CONNECTICUT STATE LIBRARY, *Hartford*
DARTMOUTH COLLEGE GALLERIES AND COLLECTIONS, *Hanover, New Hampshire*
DEERFIELD ACADEMY
ESSEX INSTITUTE, *Salem*
FAIRFIELD HISTORICAL SOCIETY
MISS JULIA T. GREEN
COLLECTION OF STEWART E. GREGORY
HEIRS OF ELISHA DENISON
HISTORICAL SOCIETY OF OLD NEWBURY
MRS. JACOB M. KAPLAN
MR. AND MRS. BERTRAM K. LITTLE
MUSEUM OF FINE ARTS, *Boston*
MUSEUM OF FINE ARTS, *Springfield*
NATIONAL GALLERY OF ART
NEW HAVEN COLONY HISTORICAL SOCIETY
NEW ENGLAND HISTORIC GENEALOGICAL SOCIETY, *Boston*
NEW ENGLAND MEDICAL CENTER HOSPITAL, *Boston*
OLD COLONY HISTORICAL SOCIETY, *Taunton*
OLD STURBRIDGE VILLAGE
MISS MARY P. PALMER
PENNSYLVANIA ACADEMY OF THE FINE ARTS
THE PHILLIPS EXETER ACADEMY
THE RHODE ISLAND HISTORICAL SOCIETY
SHELBURNE MUSEUM
SOCIETY FOR THE PRESERVATION OF NEW ENGLAND ANTIQUITIES
WADSWORTH ATHENEUM, *Hartford*
WORCESTER ART MUSEUM
YALE UNIVERSITY ART GALLERY
PRIVATE COLLECTIONS

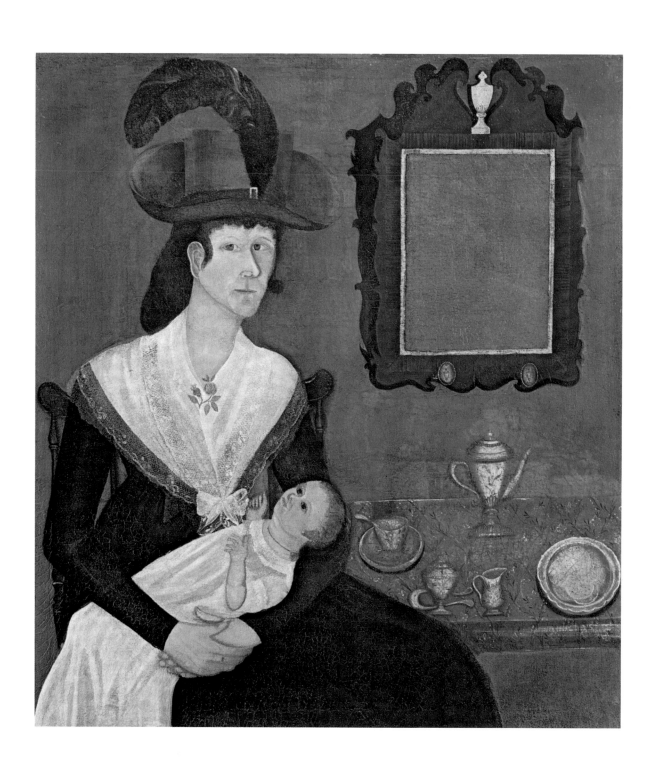

RICHARD BRUNTON . *Mrs. Reuben Humphreys* (no. 23)

Introduction

THE LAST QUARTER of the eighteenth century brought many changes
to the American colonists; they witnessed years of war, a declaration
of independence, the signing of a treaty of peace, and finally the
adoption of a definitive constitution. The accompanying political
turmoil, in addition to individual sacrifice and hardship, gradually
created a fresh, democratic outlook among many New Englanders. In
this new society aspiring portrait painters played a significant role.

The American colonists were referred to in Britain as "provincials"
because they were considered "countrified." The New Englanders
who painted their likenesses in the post-Revolutionary period were
also provincial in that they were remote not only from the European
centers of art but also from American cultural centers. Many, in fact,
worked in areas where portraiture was looked upon as a craft rather
than an accepted profession. Of the thirty-four artists included in this
exhibition, half are known to have been skilled artisan-painters.

During the mid-eighteenth century the foremost center of cultural
activity in New England was Boston, where such artists as John
Greenwood, Joseph Blackburn, John Smibert, Robert Feke, and John
Singleton Copley ably supplied the needs of an English-oriented
society accustomed to portraiture based on a traditional academic
style. Their impressive compositions, though pleasing to the eye, were
not invariably true to life, as English mezzotints were often relied upon
as sources of detail and design.

Pre-Revolutionary New England boasted an expert group of orna-
mental painters whose varied output included the painting of coaches,
landscape panels, coats-of-arms, and signboards of many kinds.
Although they were not trained as limners, these men were by no
means unacquainted with face painting and when occasion arose were
more than willing to oblige in this respected branch of their trade.
It was from the ranks of "house, sign, and fancy" painters that some of
the most vigorous portraitists emerged at a time when newly inde-
pendent doctors, lawyers, shopkeepers, and merchants wished to
commission family pictures for posterity or as marks of position in the
local community. The relative competence of artists such as John
Durand, Joseph Steward, and the Jennyses suggests the probability of
professional instruction, but how much they may have received and
from whom has not been recorded. Many others, among them Rufus

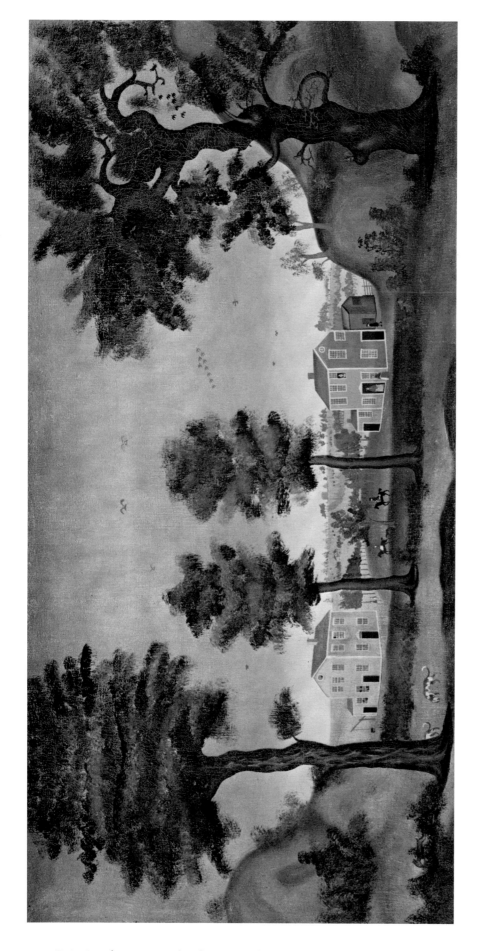

WINTHROP CHANDLER . *Homestead of General Timothy Ruggles* (no. 28)

Hathaway, Richard Brunton, and Winthrop Chandler, appear to have been virtually self-taught.

Attracted by the prospect of a fresh start in life, two enterprising Europeans, Christian Gullager and Michele Felice Corne, emigrated to the young republic. Here their foreign traditions and training enriched the quality of American indigenous art. Others, such as Abraham Delanoy, John Trumbull, and Ralph Earl, reversed the process and spent a few profitable years in the London studio of Benjamin West. Earl, in fact, lived for seven years in England, returning in 1785 to paint the country cousins who were enjoying prosperity after the war.

In contrast to the bust and waist-length likenesses usually executed by nineteenth century itinerants, artists of the previous generation favored full or three-quarter figures on canvases of ample size. Anatomy and perspective were frequently considered unimportant or were not well understood, but they were often compensated for by a great sense of color and design. Family portraits had once been the prerogative of the urban upper classes, but following the war they became available to all because acceptable artists could be found near at hand, demand creating supply.

The middle-class society of the Federal period (many members of which were college graduates) was surprisingly unselfconscious and quite willing to be depicted in realistic, if unflattering, terms. The stimulating quality of these frank portrayals is due in large part to the ingenuous acceptance by both artists and sitters of naive renderings resulting from the limitations imposed by self-taught technique. Facial blemishes, crossed eyes, and missing upholstery tacks were all recorded with clarity and candor. In contrast to the stiffly posed figures, faces are powerful and strong, and projection of personality is vivid even if gained by elementary means. These painted images reveal the tense expressions of men and women whose adult lives spanned the uneasy years that culminated in the Revolution and continued through the War of 1812.

Though lacking in formal training, late eighteenth century artists were quite conversant with the traditions of academic art. Classical columns, voluminous drapery, and background window views are only a few of the conventional devices that were not necessarily allied to the personal surroundings of the sitters. Meaningful symbols, nevertheless, were at times introduced, such as ships to suggest a seafaring man or calf-bound books with appropriate titles. A letter dated 1797 to Dartmouth College from Joseph Steward, arranging for transportation to Hanover of his portrait of Eleazer Wheelock, contains the following request: "I must beg the favor of him [Mr. Josiah Dunham] to letter one book, which I have left undone, not knowing what author

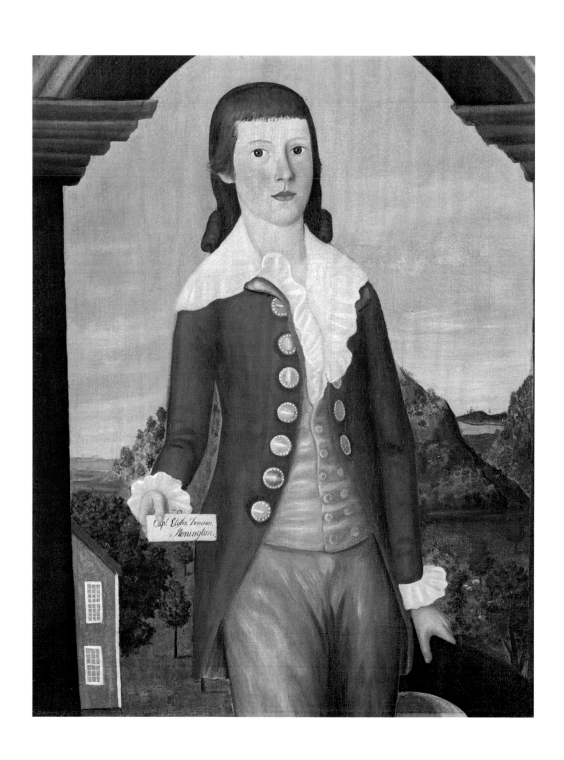

12 DENISON LIMNER. *Elisha Denison* (no. 34)

or title would be the most pleasing to put on it." In this picture (no. 73) the volume still remains untitled.

As already noted, landscape vignettes were an accepted element in eighteenth century portraits, but scenic paintings to hang upon a wall were rarely found, for it was not until the nineteenth century that they attained wide popularity. With the exception of Ralph Earl, most provincial artists regarded landscapes as architectural decoration and painted them on the wooden paneling above a fireplace. Many over-mantels exhibiting a variety of themes have been discovered in eighteenth century houses where a traveling artist had once paused to decorate the woodwork of the principal rooms. Some compositions illustrate typical New England scenes either actual or composed, while other subjects owe inspiration to imported engravings.

IN ASSEMBLING this exhibition preference has been accorded to pictures that are inscribed, documented, or confidently attributed to a recognizable, if unidentified, hand, thereby providing key examples for further comparison and study. Undocumented examples are listed under an artist's name only if widely accepted as his work. Otherwise, they appear under the heading "Anonymous Artists," and attributions, if any, are suggested in the text. If pertinent information relative to an artist or sitter has been previously published in concise form, references are cited. If details derive from many sources or are fragmentary or obscure, they have been combined, and individual footnotes are omitted.

It will be readily apparent that a few of the portraits were painted shortly before, or after, the limiting dates of 1775-1800. All the pictures, however, have been chosen to illustrate the characteristics typical of the final quarter of the eighteenth century.

During the past thirty years many individuals and institutions have made valuable contributions to the field of American art history by furthering research and study of hitherto obscure New England artists. In the 1940's, under the guidance of Louisa Dresser, the Worcester Art Museum presented the first comprehensive showing of the works of Christian Gullager and Winthrop Chandler. The fall of 1945 saw a noteworthy exhibition of paintings by Ralph Earl, of which the descriptive catalogue by William Sawitzky served as the basis for subsequent publications dealing with Earl's work. The autumn of 1952 witnessed the initial presentation by the American Wing of the Metropolitan Museum of Art of a little-known group of eighteenth century American landscapes. This pioneer exhibit was followed in the mid-1950's by the first of a series of important study

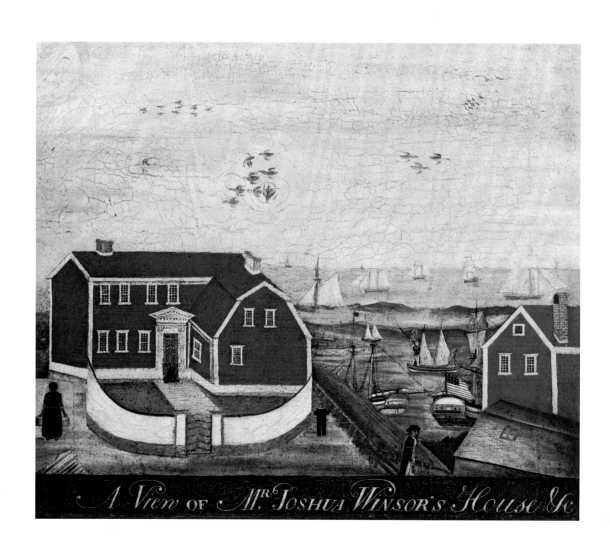

A View of Mr. Joshua Winsor's House &c

14 RUFUS HATHAWAY . *Joshua Winsor's House* (no. 51)

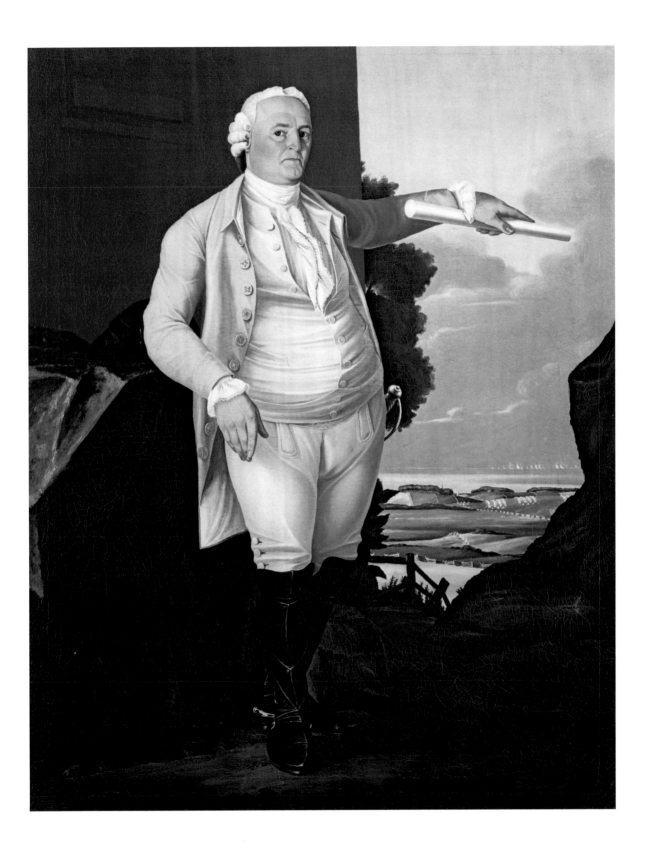

15　JOHN TRUMBULL . *Major-General Jabez Huntington* (no. 74)

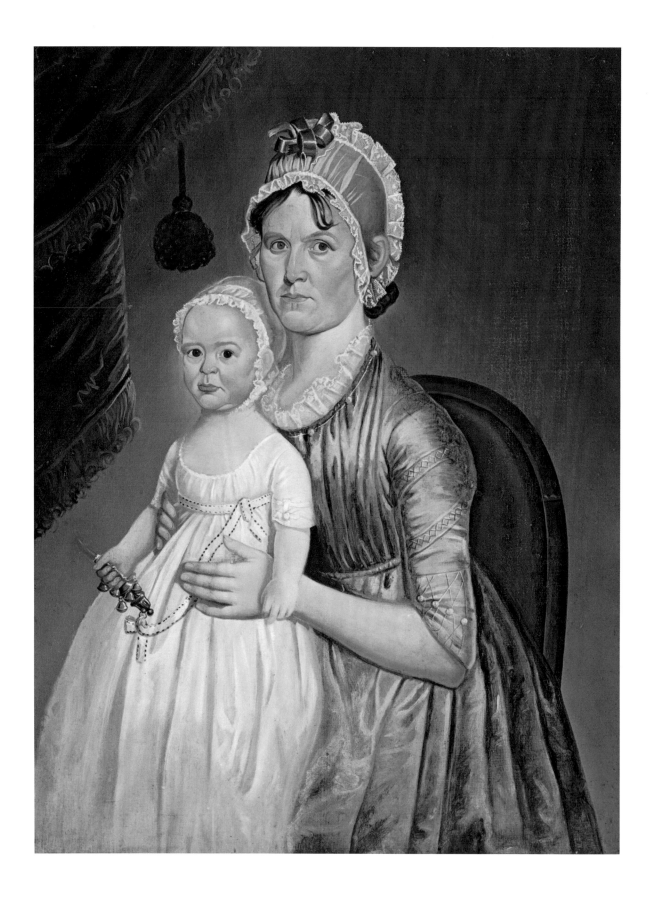

16　WILLIAM JENNYS. *Mrs. Cephas Smith, Jr.* (no. 56)

exhibitions carefully researched and organized by William L. Warren with the enthusiastic cooperation of Thompson R. Harlow, director of the Connecticut Historical Society. With the assistance of several guest curators, outstanding works by William Johnston, Simon Fitch, Joseph Steward, Reuben Moulthrop, John Brewster, Jr., and several groups of anonymous Connecticut artists were catalogued and hung by the society. More recently, other museums have continued the display of significant examples of indigenous American art. Nevertheless, a comprehensive exhibition that comprises seventy-six paintings by thirty-four artists active in the immediate post-Revolutionary period has not previously been assembled. It is hoped, therefore, that the special quality of the representative pictures shown here will assure New England provincial painters the recognition they have so long deserved.

NINA FLETCHER LITTLE

Artists and Paintings

Anonymous Artist

1 *Colonel David Mason*
Oil on canvas, 29½ x 24½ in.
Essex Institute, Salem, Massachusetts

David Mason (1726-1794) was born in Boston, son of David and Susanna (Stevens) Mason. A child's silver porringer, still owned by descendants, is engraved with his name and bears the mark of Paul Revere I. Mason was an artisan-painter by profession, but when twenty-six years of age he followed his father as a member of Boston's Ancient and Honorable Artillery Company and embarked on a lifetime of intermittent military service. In 1756, with the rank of captain in the British artillery, he fought in the French and Indian War and was captured at the surrender of Fort William Henry. In 1763 he was appointed captain-lieutenant of the Artillery Company of the Boston Regiment by Governor Barnard, and the blue and scarlet uniform shown in the portrait appears to date from this time. The Artillery Company, which Mason raised, was composed of mechanics and shopkeepers like himself from Boston's South End.

In 1765, due to a smallpox epidemic, he left Boston for Cape Ann and later moved to Salem, where he continued his pioneer studies "on the nature and Properties" of electricity. At his Salem home in 1771 he offered public lectures and exhibitions of his electrical experiments at the price of one pistareen (about 20 cents). It was the British search for Mason's ordnance stores on February 26, 1775 (hidden near the North Bridge, Salem, and later in Concord) that helped to fan the first flames of the American Revolution. He commanded a battery during the siege of Boston, fought with Washington at Long Island, and established the Springfield Arsenal of which he was in charge until his retirement from active service in 1781.

In 1742, at the age of fourteen, Mason was apprenticed to John Gore, gilder, coach, and carpet painter. He worked under Thomas Johnston, engraver, japanner, and painter of armorial devices, and studied portraiture with John Greenwood before his departure for Surinam in 1752. Family tradition maintains that Mason's likeness is a self-portrait. In 1758, just returned from the French and Indian War, he advertised in the *Boston Gazette* japanning, gilding, coats-of-arms, and drawings for embroidery. A similar notice appeared in the *Essex Gazette* in July 1770. In recognition of his combined artistic and military accomplishments, Mason was selected to lead the marching group of Limners and Portrait Painters in the procession of Artisans, Tradesmen and Manufacturers that celebrated President Washington's official visit to Boston on October 24, 1789.

David Mason's portrait has been chosen as the first in this exhibition because it typifies the bland, almond-eyed countenance so often seen in pre-Revolutionary artisan painting. In direct contrast, the faces of Mr. and Mrs. Silas Casey (nos. 2 and 3) project the forceful personalities of real people. This direct and literal approach, though at times unflattering, was to become a dominant characteristic of post-Revolutionary provincial portraiture.

Ref.: "Biographical Sketch of Col. David Mason by his Daughter Mrs. Susan Smith, June, 1824." *Historic Collections of the Essex Institute* 48 (1912), 1-20.

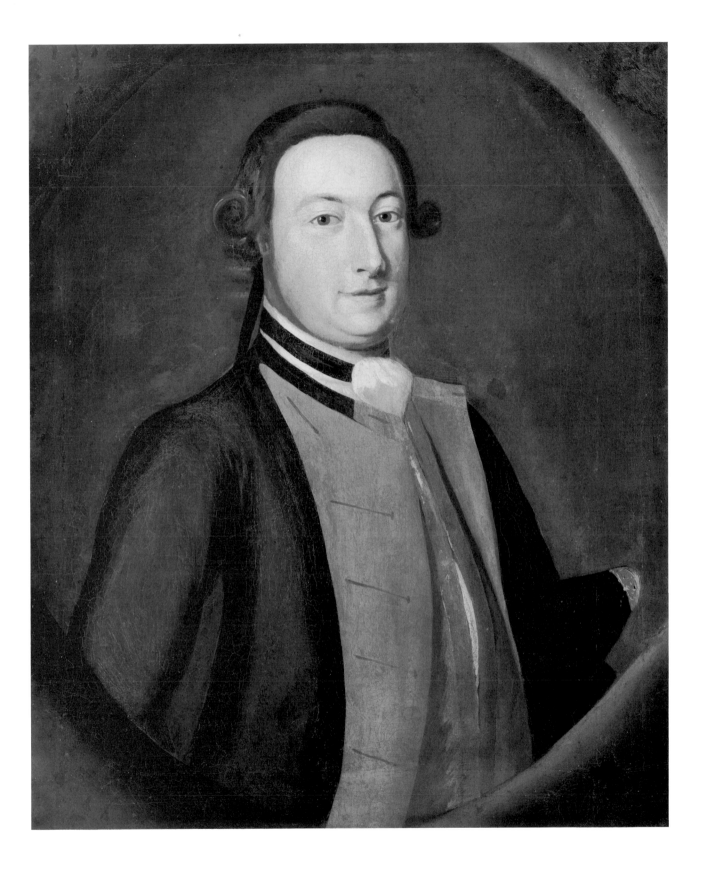

23 ANONYMOUS ARTIST. *Colonel David Mason*

Anonymous Artist

2
Silas Casey
Oil on canvas, 27 x 21 ¼ in.
Society for the Preservation of New England Antiquities, Boston,
Massachusetts

Silas Casey (1734-1814) of East Greenwich, Rhode Island, was the son of Thomas
and Comfort (Langford) Casey. By the age of twenty-five, he was well launched on
a mercantile career that made him one of the most prominent shipowners of
Narragansett Bay. Casey-owned vessels sailed to England and the West Indies and
fished on the grounds off Labrador. The operator of four privateers during the
Revolution, he sustained unfortunate losses through the capture of some of his
vessels.

The unknown artist has portrayed Casey gazing directly at the viewer with a
shrewd and penetrating eye, his ruddy features heavily accented with gray shad-
ows. The otherwise sober composition is cleverly lightened and amplified by a
distant seascape against which one side of his face is boldly silhouetted. Com-
parison of this picture with the earlier portrait of Colonel David Mason (no. 1)
illustrates the difference in style to be found in provincial painting before and after
the Revolution.

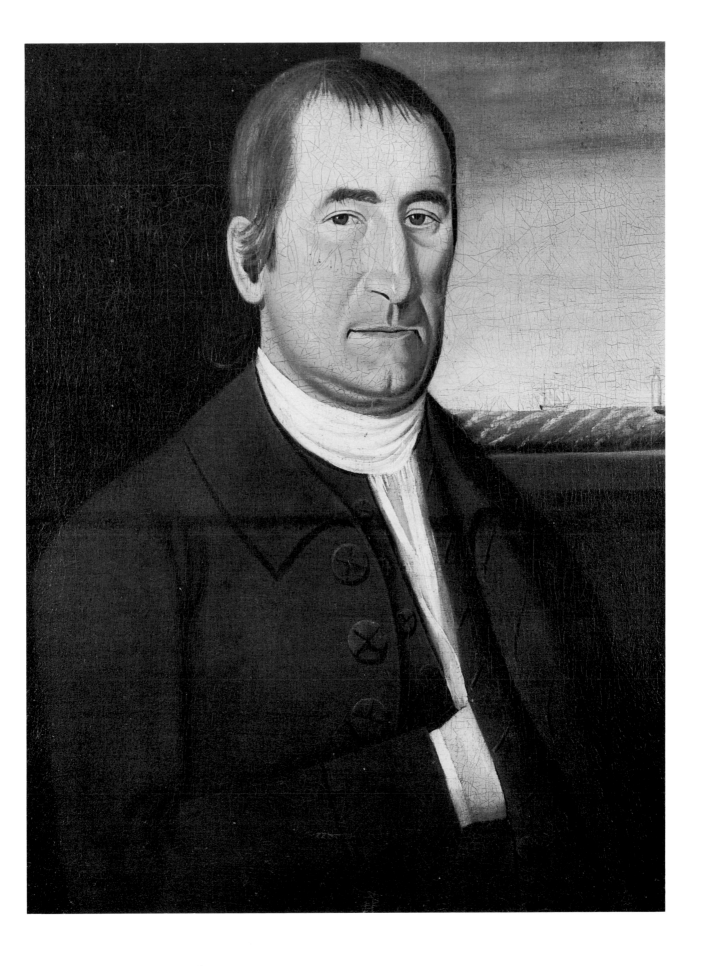

25 ANONYMOUS ARTIST. *Silas Casey*

Anonymous Artist

3 *Mrs. Silas Casey*
Oil on canvas, 27 x 21 ¼ in.
Society for the Preservation of New England Antiquities, Boston,
Massachusetts

The daughter of Daniel and Mary (Wanton) Coggeshall of Scituate, Massachu-
setts, Abigail Coggeshall (1736-1821) married Silas Casey on June 7, 1759. One
son, Wanton, was born in 1760. Subsequently they and four successive generations
of Caseys lived on the large, mid-eighteenth century farm in North Kingston,
Rhode Island. She and her husband are buried in the small family graveyard, and
nearby is the old farmhouse where the pictures are still shown in their accustomed
places in the parlor.

 Few untrained artists ventured to paint their sitters full face, but Mrs. Casey's
uncompromising likeness is successful in its simplicity of composition and in the
muted palette that accentuates the prominence of the strongly modeled face.

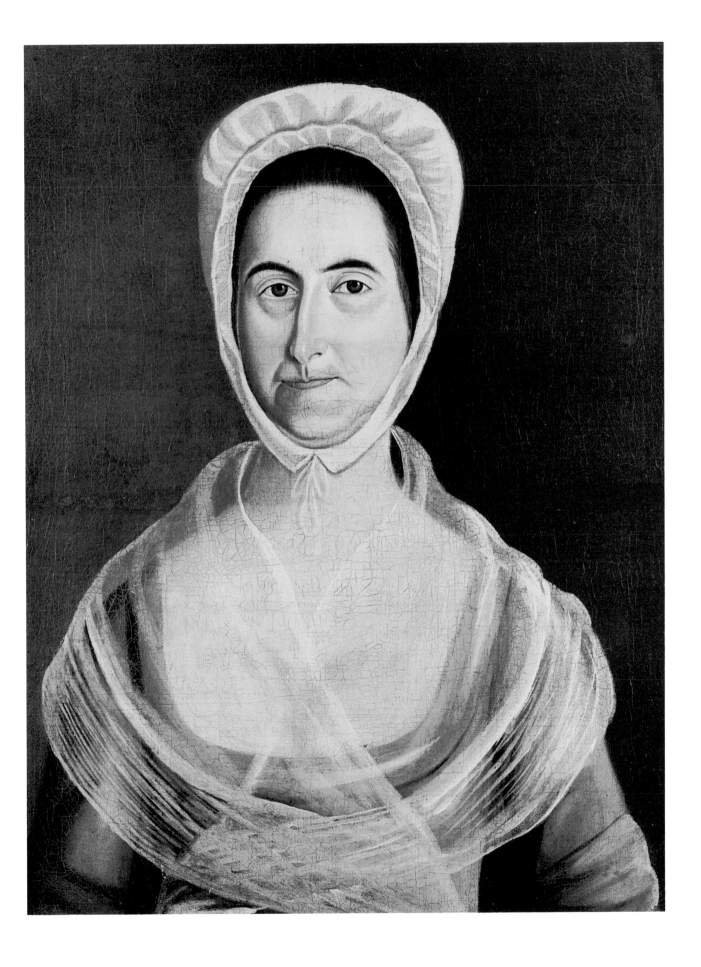

27 ANONYMOUS ARTIST. *Mrs. Silas Casey*

Anonymous Artist

4 *Overmantel from the Gardiner Gilman House, Exeter,*
New Hampshire
Oil on wood, 28 x 47¾ in.
Amon Carter Museum, Fort Worth, Texas
Purchased by the Trustees of the Amon Carter Museum
in memory of Harry D. M. Grier, Trustee

This picture was originally part of a paneled fireplace wall in the Gardiner Gilman house in Exeter, New Hampshire. The subject shares various characteristics with other overmantels of the late 1790's and seems to be a combination of real and imaginary elements. The large white mansion on the left and many of the colorful buildings clustered in the town represent New England Federal architecture at the height of its prosperity. It is possible, however, that the overall composition was inspired by an engraved source. Executed by a number of anonymous artisan-painters who traveled from town to town, decorative overmantels of this type enlivened many interiors during the last quarter of the eighteenth century.

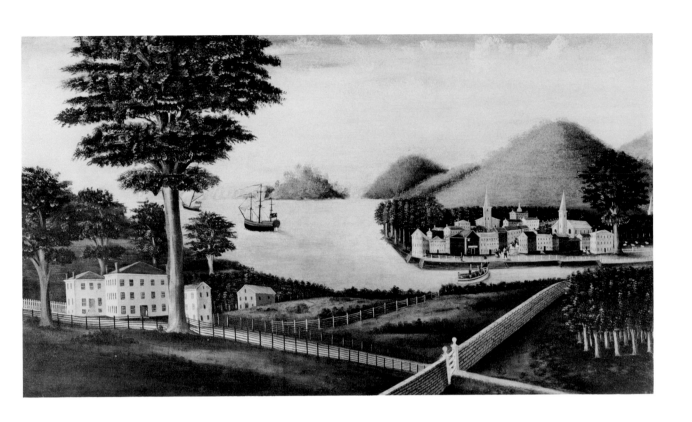

29 ANONYMOUS ARTIST. *Overmantel from the Gardiner Gilman House*

Anonymous Artist

5
Judge Jonathan Sayward
Oil on canvas, 50 x 39 in.
Original gold frame
Private Collection

Jonathan Sayward (1713-1797) of York, Maine, took part in the Siege of Louisburg under Sir William Pepperrell in 1745. He was actively engaged in shipping (two vessels are shown in the background) and was commissioned by the British Governor Shirley to command the sloop *Sea Flower*. A representative to the General Court in Boston for seventeen years, he was also judge of the Court of Common Pleas and of the Probate Court of York County, Maine. His diary, covering the years from 1760 to 1797, is owned by the American Antiquarian Society.

A wealthy and prominent British sympathizer, Judge Sayward carried gold coins and currency valued at £200 on his person during the uneasy years when he feared being run out of town as a Tory. The companion portrait of his wife, Sara Mitchell, was never completed. This has given rise to the legend that the unknown artist left the house abruptly on hearing that the rebels were coming and escaped across the river, never to return. A more likely explanation is the fact that Mrs. Sayward died in 1775, perhaps when the pictures were in the process of being painted. Following the war the judge remained in York and eventually regained the confidence of his fellow townsmen. Although executed by a relatively unskilled hand, the composition of this impressive picture recalls the pose and style characteristic of pre-Revolutionary Boston portraiture.

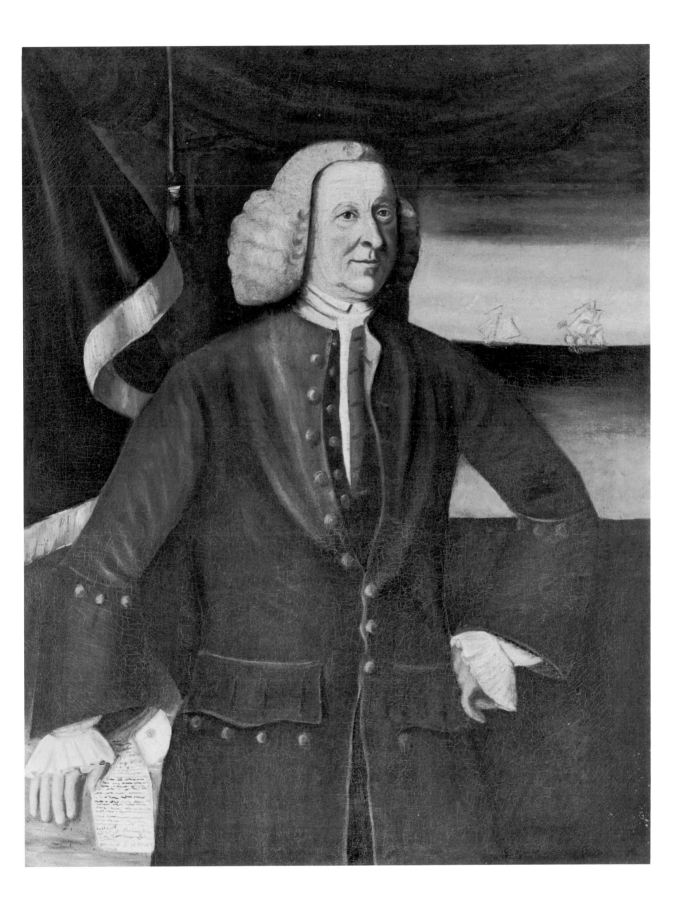

31 ANONYMOUS ARTIST. *Judge Jonathan Sayward*

Anonymous Artist

6 *View of the John Hancock House, Boston* (fireboard)
 Oil on canvas, 30½ x 50¼ in.
 Private Collection

The house was built of stone by Thomas Hancock, uncle of the governor, in 1737. The property fronted on Beacon Street, overlooking Boston Common, and stood just to the west of the present State House. At the left one observes the coach house and stable and at right the seventeenth century beacon on the summit of Beacon Hill. This ancient landmark was blown down during the night of November 26, 1789. It was replaced in 1790 with a sixty-foot monument surmounted by a gilded eagle, but this in turn was demolished in 1811 during the lowering of Beacon Hill. Generals Washington and Lafayette and many other distinguished guests were entertained by John Hancock, and the house and stables were partly occupied by the wounded after the Battle of Bunker Hill. By the mid-nineteenth century the Hancock land had risen greatly in speculative value, but efforts were initiated to preserve the house for use by either the city or state. When these endeavors failed, the historic mansion was torn down in 1863.

This scene presents one of the most important early views of the Hancock House, its outbuildings, and their eighteenth century surroundings. A less comprehensive engraved view was published in the *Massachusetts Magazine* in 1789. The painting was originally the property of John Hancock, by whom it is said to have been given to the patriot Samuel Adams for use as a fireboard.

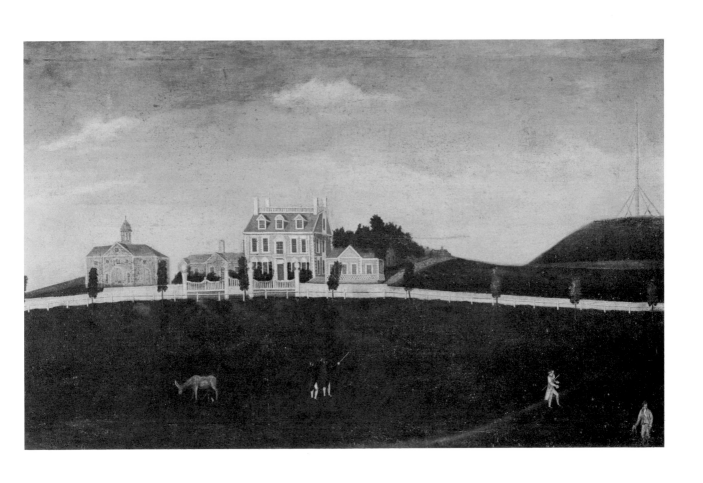

33 ANONYMOUS ARTIST. *View of the John Hancock House*

Anonymous Artist

7 *Mr. and Mrs. Nathaniel Seaver, Jr.*
Oil on canvas, 63 x 44 in.
Attributed to Samuel King
Brookline Historical Society, Brookline, Massachusetts

Nathaniel Seaver, Jr. (1754-1792) and his wife, Susanna White (1756-1832), were both descendants of early Brookline families. Following their marriage in 1775, he became a merchant in Boston. On January 27, 1792, he embarked from Salem, with his sixteen-year-old son Nathaniel as supercargo, on a voyage to Madras. The ill-fated ship *Commerce* was owned by Seaver and one Robert Williams. The vessel was blown far off course, and on the night of July 10 she foundered off the coast of Arabia. Young Seaver and two companions were drowned while trying to swim ashore. During the ensuing five weeks' struggle to reach Muscat on foot, Nathaniel Seaver and five others perished, leaving only eight of the original seventeen white men to return to Salem. Susanna Seaver's second husband was Samuel Gore, an ornamental painter with a shop on the corner of Court and Brattle Streets, Boston.

Mrs. Seaver's delicate silk gown, the brocaded arm chair, her husband's silver shoe buckles, and the red Turkey-pattern carpet beneath their feet convey the appearance of elegance and prosperity. The corner vignette probably depicts an island in Boston harbor introduced as background for one of Seaver's ships. This dual portrait was an ambitious but quite successful effort despite the stiff posture and awkward position of Mrs. Seaver's right arm. The attribution to Samuel King is supported by comparison with other of his known works (see, for example, nos. 63, 64).

See also colorplate, frontispiece, p. 2.

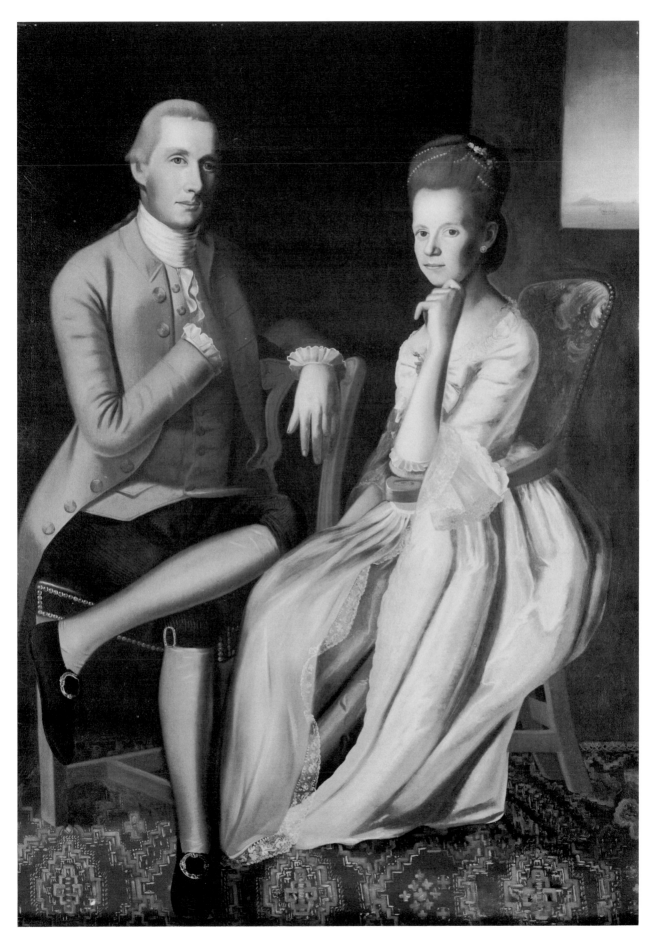

35 ANONYMOUS ARTIST. *Mr. and Mrs. Nathaniel Seaver, Jr.*

Anonymous Artist

8 *Seat of Colonel George Boyd*, Portsmouth, New Hampshire
Oil on canvas, 17 x 32 in.
Inscribed on the rock in foreground:
"The South West Prospect/of the Seat of Colonel George Boyd/
at Portsmouth New Hampshire/New England. 1774."
Original gold frame
The Phillips Exeter Academy, Exeter, New Hampshire

George Boyd (1733-1787) came to Portsmouth as a young man and became fore-man of a ropewalk owned by an Englishman named Myrick. After Myrick mys-teriously disappeared during a trip to Jamaica, Boyd became known as a trader who drove a hard bargain. Between 1767 and 1770 he purchased the mill, shipyard, and home of Peter Livices. He greatly enlarged the mansion and he also developed the fine garden shown in the painting, importing an English gardner for its care. An imposing fence faced the house, supported at intervals by four wooden posts sur-mounted by carved grenadiers' heads. Boyd departed for England at the start of the Revolution, although his family continued to occupy the house. In August 1787, he set sail on the return journey to Portsmouth, bringing an English coach and coachman and an elegant monument to mark his grave. He never returned to live in America, however, as he died on the voyage home.

 Scenes drawn in such detail are rare in eighteenth century art. This one shows the North Mill Bridge in Portsmouth built in 1761, with the mill, dwellings, and storehouses that were known because of their color as the "white village." The Boyd property, originally extending to the later site of the Boston and Maine Rail-road depot, became in the mid-nineteenth century the home and shipyard of George Raynes. Many famous clipper ships were launched from his yard.

Ref.: Charles W. Brewster, *Rambles about Portsmouth*, First Series, (Portsmouth, 1873), p. 165.

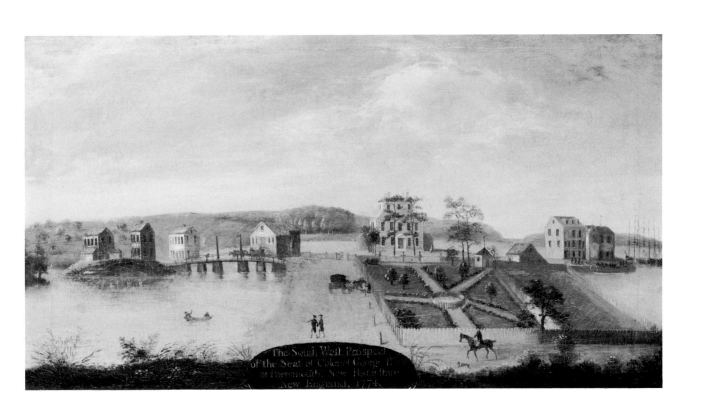

The South West Prospect
of the Seat of Colonel George Boyd
at Portsmouth, New Hampshire
New England, 1774.

37 ANONYMOUS ARTIST. *Seat of Colonel George Boyd*

Anonymous Artist

9 *James Blakeslee Reynolds*
Oil on canvas, 45 x 36 in.
Mr. and Mrs. Bertram K. Little

James Blakeslee Reynolds (1754-1834) was the son of James and Mehitabel Reynolds. He lived in West Haven, Connecticut, where he is said to have been a farmer. His portrait shows a brass snuffbox resting on a book beside him and his tricorne hat hanging on the wall at left. A small tear in the original canvas was later patched with a Connecticut newspaper dated April 21, 1797, suggesting the date of the repair.

Although the Reynolds pictures have been ascribed to Reuben Moulthrop, they pose an interesting problem in attribution. They comprise two of a group of five portraits that all exhibit very similar characteristics. One of the five depicted Mrs. Hannah Street, Moulthrop's mother-in-law. This picture is now known only through an old photograph, but the companion portrait of Hannah's husband, the Reverend Nicholas Street, is signed on the stretcher with Moulthrop's initials and has long been accepted as his work. The Reynolds portraits were included in an exhibition of Moulthrop's work shown at the Connecticut Historical Society in 1956. Since then, however, the ascription has been questioned on both aesthetic and technical grounds. There the matter presently rests until consideration of further evidence indicates a firm attribution for these handsome pictures.

Refs.: Susan Sawitzky, "Early Work of Reuben Moulthrop," *Art in America* 44, no. 3 (Fall, 1956), 384-505; Samuel M. Green II, "Some Afterthoughts on the Moulthrop Exhibition," *Connecticut Historical Society Bulletin* 22, no. 2 (April, 1957), 33-45.

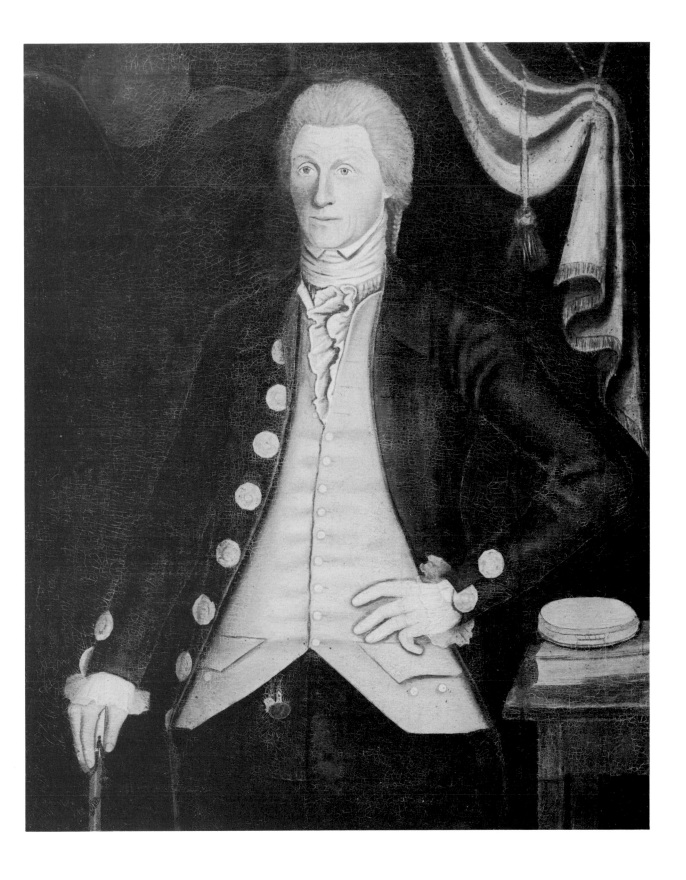

39 ANONYMOUS ARTIST. *James Blakeslee Reynolds*

Anonymous Artist

10 *Mrs. James Blakeslee Reynolds*
Oil on canvas, 45 x 36 in.
Mr. and Mrs. Bertram K. Little

Mary (Kimberly) Reynolds (1754-1833) of North Haven, Connecticut, was the daughter of Israel and Mary (Tolles) Kimberly. Her first husband was Captain Seth Thomas (son of Charles and Lydia (Augur) Thomas of West Haven, Connecticut), with whom she probably moved to Newburyport, Massachusetts, as he died there in 1782. A son, William, was born the same year and was buried in Newburyport in 1798. Mary Kimberly married James Blakeslee Reynolds of West Haven about 1788, and it is probable that their portraits were painted in 1789.

Her severe, masklike visage is flat and unshaded, her figure elegantly clothed but lacking in anatomical verity. Yet the well-organized composition, balanced by drapery and a decorative flowering plant, exhibits the flair for effective design that imparted vitality to so many provincial portraits.

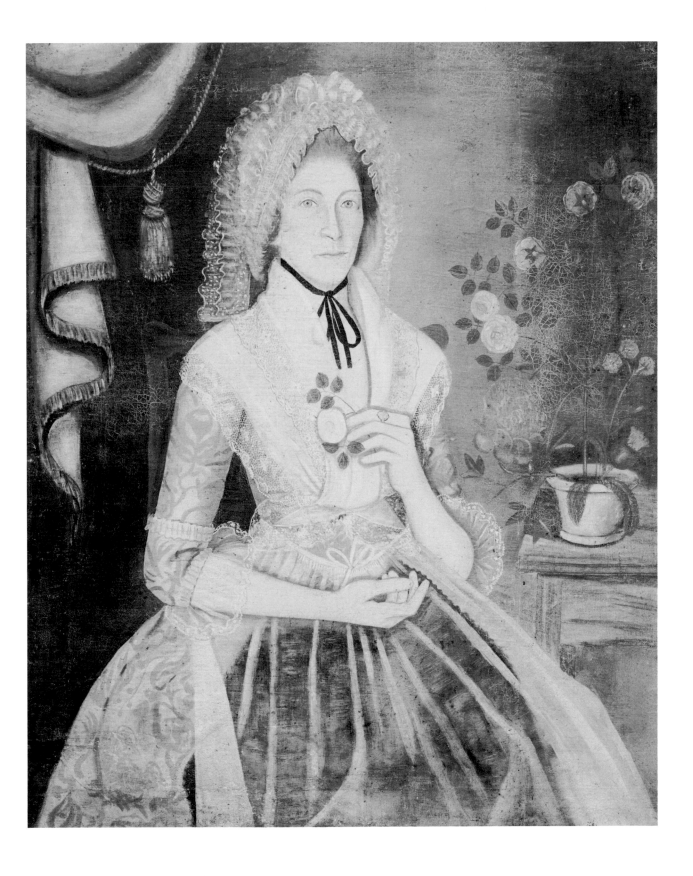

41 ANONYMOUS ARTIST. *Mrs. James Blakeslee Reynolds*

Anonymous Artist

11 *House in Fairfield, Connecticut* (overmantel landscape)
Oil on wood, 25 x 41⅛ in.
Attributed to J. Budington
Fairfield Historical Society, Fairfield, Connecticut

Little definite information is available concerning the history of this overmantel landscape. It is traditionally said to represent Main Street in Fairfield, possibly the Beers property, and to have been a part of the woodwork in the home of Elisha T. Mills. Although neither of these is still standing, the picture gives every indication of presenting an actual scene. The gambrel-roof gray house, with white trim and blue front door, contrasts pleasantly with the red barns at right and other early buildings nearby.

 The overmantel has been tentatively attributed to Jonathan Budington because of similarity in style to a view of houses and shipping at Cannon's Wharf, New York City, which was signed and dated by him in 1792. Budington is believed to have been born in Fairfield and is known to have painted portraits of several Fairfield people (nos. 24, 25).

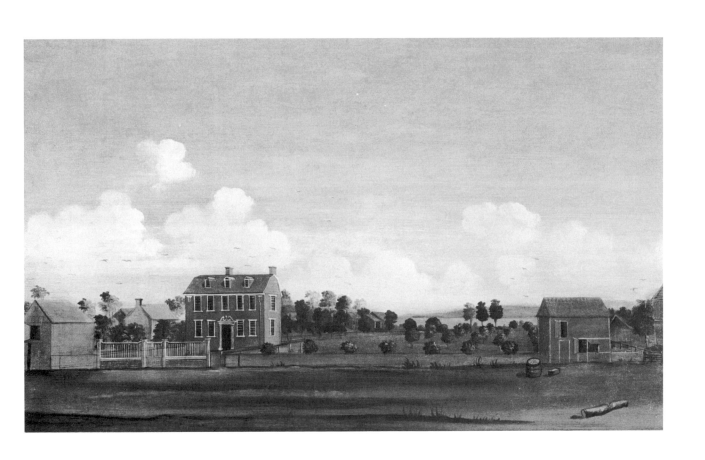

43 ANONYMOUS ARTIST. *House in Fairfield, Connecticut*

Anonymous Artist

12 *Timothy Swan*
Oil on canvas, 40 x 33 in.
Original black and gold frame
American Antiquarian Society, Worcester, Massachusetts

Timothy Swan (1758-1842) was born in Worcester, Massachusetts, a descendant of Thomas Swan, who settled in Roxbury prior to 1681. When a young man, Swan learned the trade of hatter but later became known as a composer and compiler of psalm and hymn tunes, and the author of some secular music and verse. His musical education, it is said, was limited to three weeks participation in a singing school plus brief instruction on the fife from a British musician. He moved from Northfield, Massachusetts, to Suffield, Connecticut, in 1782, where two years later he married Mary, daughter of the Reverend Ebenezer Gay. Several books of his music and other papers are in the collections of the American Antiquarian Society.

The identity of the artist remains unknown, although this forthright portrait was apparently the work of a "house, sign, and fancy" painter who had access to engravings that he used as sources of background designs. The stiff, angular pose and meticulously ornamented coat buttons and embroidered vest strongly suggest the brush of a professional decorator. The extensive view stretching beyond the open window has no relation to the actual surroundings of the Swan home, which still stands near the Suffield green. The architectural style of the house and the curious form of the canopied barge on the river were not indigenous to the early New England scene. Similar elements, however, do appear in a second Suffield picture. The latter is an overmantel landscape in the Alexander King house and is undoubtedly by the same hand as the Swan portrait. The overmantel represents a simplified version of a mid-eighteenth century engraving picturing the River Thames above London, and there is little doubt that the background of the Swan portrait was also based on a similar English engraving. Swan is known to have had a strong predilection for things Scottish. His favorite author is reputed to have been Robert Burns, and much of the verse that he composed for the local paper was written in Scottish dialect. Perhaps because of his sitter's interest, the artist inserted in one corner of the window view two tall-hatted bagpipe players—a subtle allusion that should not be overlooked.

See also colorplate, p. 6.

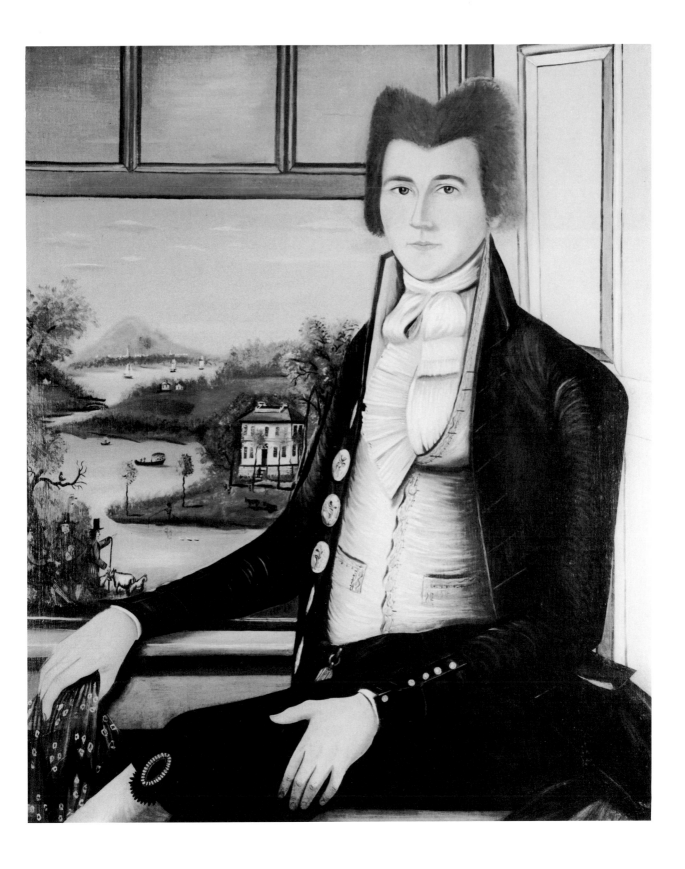

45 ANONYMOUS ARTIST. *Timothy Swan*

Beardsley Limner (active 1785-1805)

13 *Oliver Wight*
 Oil on canvas, 31¼ x 25½ in.
 Abby Aldrich Rockefeller Folk Art Collection, Williamsburg, Virginia

Oliver Wight (1765-1837) was born in Sturbridge, Massachusetts, and lived there on and off during his lifetime. He was a cabinetmaker and in the late 1780's built the large, foursquare mansion that still stands on the property of Old Sturbridge Village. It was probably at this prosperous period in his life that the portraits of him and his wife were painted, depicting him in gray coat, blue vest, and silver-headed cane, posing as a debonair country squire. Long plagued by debts, he sold his house and began to travel in search of better fortune, but he eventually returned to Sturbridge, where he died in 1837, leaving an estate of $56.40.

The identity of the Beardsley Limner is still unknown, although his hand is recognizable in more than a dozen portraits of outstanding quality and interest. The likenesses of Dr. and Mrs. Hezekiah Beardsley (Yale University Art Gallery), painted in New Haven between 1785 and 1790, were two of the first portraits attributed to this artist. Therefore, the group is referred to by the Beardsley name. Judging by the names and ages of his sitters, the artist was active in towns adjacent to the old main road that ran through New Haven, Sturbridge, and Sudbury between 1785 and 1795. Despite lack of skill in facial modeling, his flair for color and personal detail resulted in exceptionally decorative compositions.

Refs.: Christine Skeeles Schloss, *The Beardsley Limner and Some Contemporaries* [exhibition catalogue] (Williamsburg, Va.: Abby Aldrich Rockefeller Folk Art Collection, 1972); idem, "The Beardsley Limner," *Antiques* 103, no. 3 (March, 1973), 533-538.

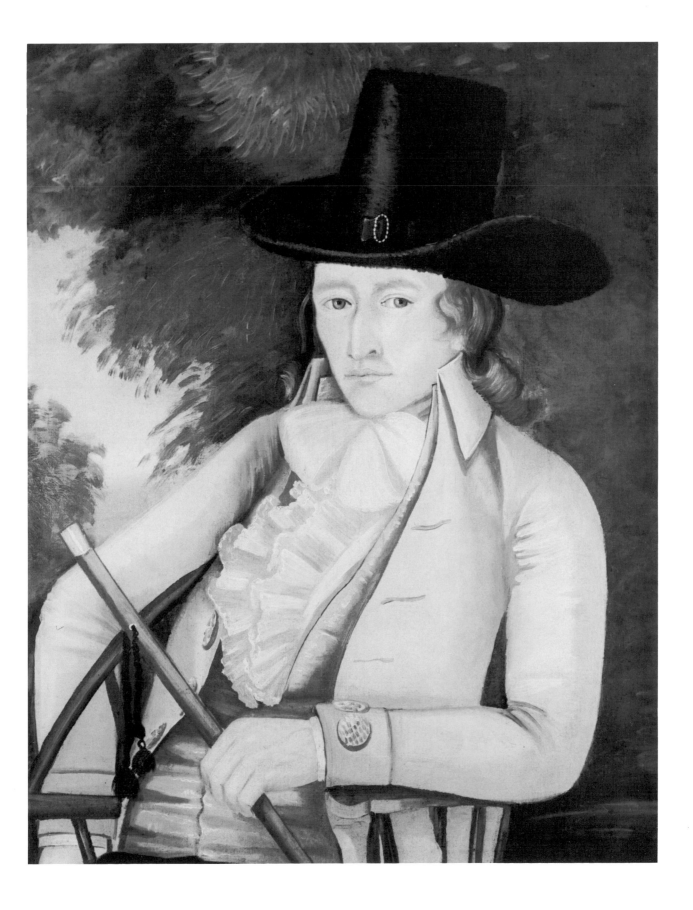

47 BEARDSLEY LIMNER. *Oliver Wight*

Beardsley Limner (active 1785-1805)

14 *Mrs. Oliver Wight*
 Oil on canvas, 31¼ x 25½ in.
 Abby Aldrich Rockefeller Folk Art Collection, Williamsburg, Virginia

Harmony (Child) Wight (1765-1861) is believed to have been born in Woodstock, Connecticut, and married Oliver Wight in 1786. She became the mother of twelve children, ten of whom were born in Sturbridge, where she died at the age of ninety-six. The design of the portrait is cleverly composed in a pattern of four triangles. Blue-fringed background drapery accentuates the head, and a pleasant sense of spaciousness is created by the suggestion of a misty landcape introduced behind the sitter.

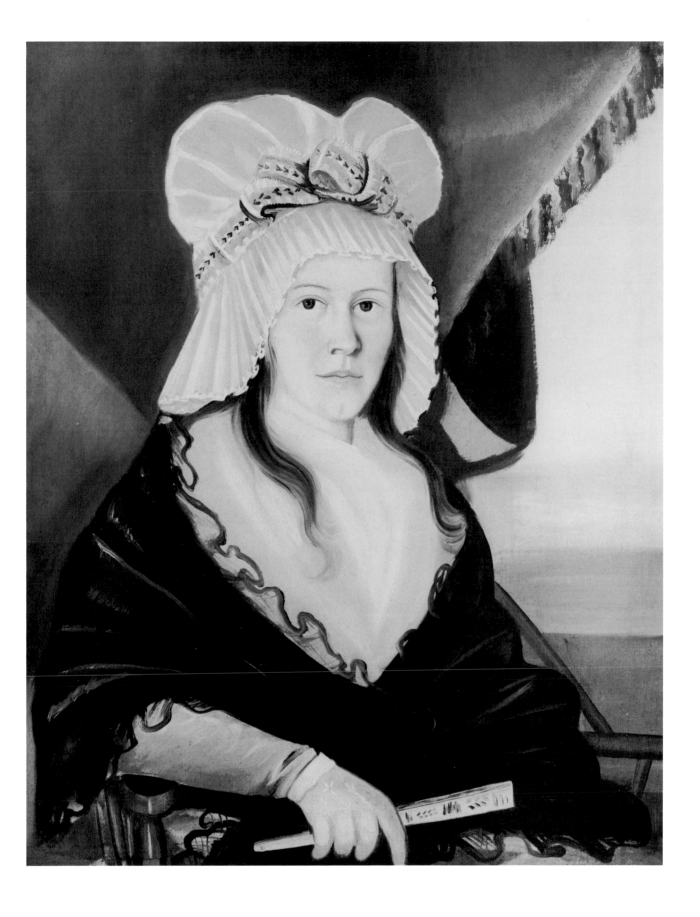

49 BEARDSLEY LIMNER. *Mrs. Oliver Wight*

Beardsley Limner (active 1785-1805)

15
Joseph Wheeler
Oil on canvas, 45 x 30½ in.
Original black and gold painted frame
Mr. and Mrs. Bertram K. Little

Joseph Wheeler (1780-1826) was the eldest son of Elisha and Mary (Adams) Wheeler. Born in Sudbury, Massachusetts, he moved before 1801 to Keene, New Hampshire, where he died at the age of forty-six years. A very similar picture of his younger brother Charles is owned by the National Gallery of Art, Gift of Edgar William and Bernice Chrysler Garbisch. Both boys exhibit the shoulder-length hair with gray overtones that is a characteristic of this artist's work.

Ref.: Nina Fletcher Little, "Little Known Connecticut Artists, 1790-1810," *Connecticut Historical Society Bulletin* 22, no. 4 (Oct. 1957), 99, 100, 106.

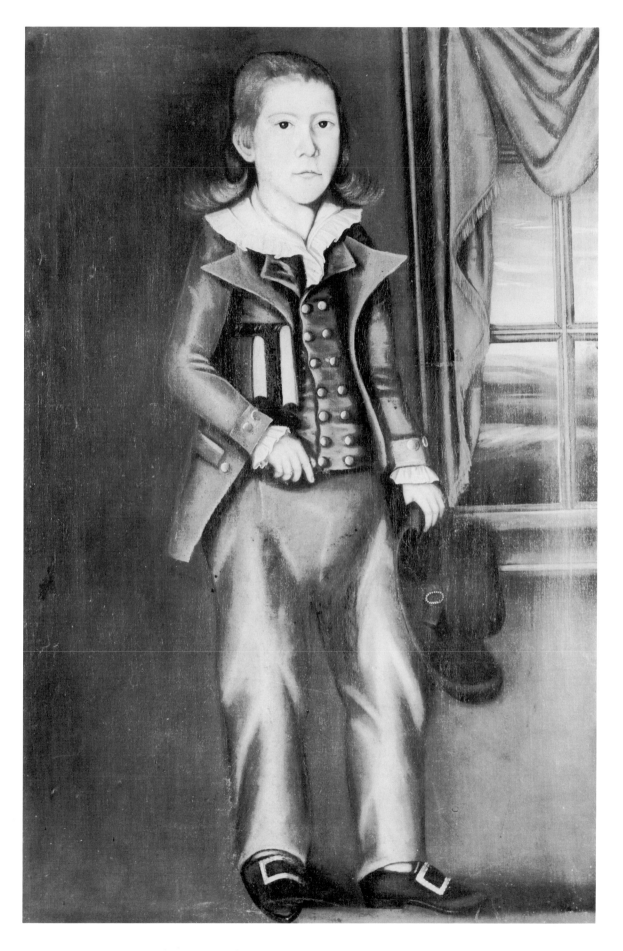

51 BEARDSLEY LIMNER. *Joseph Wheeler*

Benjamin Blyth (bapt. 1746)

16 *Benjamin Moses*
 Oil on canvas, 32 x 27 in.
 Signed below window to right of sleeve: "B/Blyth./Pinx. 1781"
 Essex Institute, Salem, Massachusetts

Benjamin Moses (1737-1803) was a Salem shipmaster during the Revolution, when he captained the privateer *Creature*, afterwards renamed the *Oliver Cromwell*. He later commanded the sloop *Indian*, a packet in the coastwise trade between Salem and Boston. The vessel in the window-view represents his seafaring interests.

Benjamin Blyth was baptised in Salem on May 18, 1746, and is best known for his many fine pastels of Massachusetts people drawn during the Revolutionary period. He apparently left Salem in the early 1780's, and his second marriage to the widow Mary Dougle was recorded in Norfolk County, Virginia, on February 12, 1785. The Moses pictures, while lacking the finesse of Blyth's delicate crayon portraits, are rare examples of his signed work in oil. Although his painting in this medium is virtually unknown in New England, he did advertise it in Richmond with a notice published in the *Virginia Gazette* during July and August 1786, which reads in part: "Benjamin Blyth Limner BEGS to inform the Public that he has opened a House near the City Coffee-House, for the performance of Limning in Oil, Crayons, and Miniature . . ." This is the last known reference to Blyth, and his subsequent career and date and place of death are presently unknown.

Refs.: Henry Wilder Foote, "Benjamin Blyth, of Salem: Eighteenth-Century Artist," *Proceedings of the Massachusetts Historical Society* 71 (Oct. 1953-May 1957), 64-107; Nina Fletcher Little, "The Blyths of Salem," *Essex Institute Historical Collections* 108, no. 1 (Jan. 1972), 49-57.

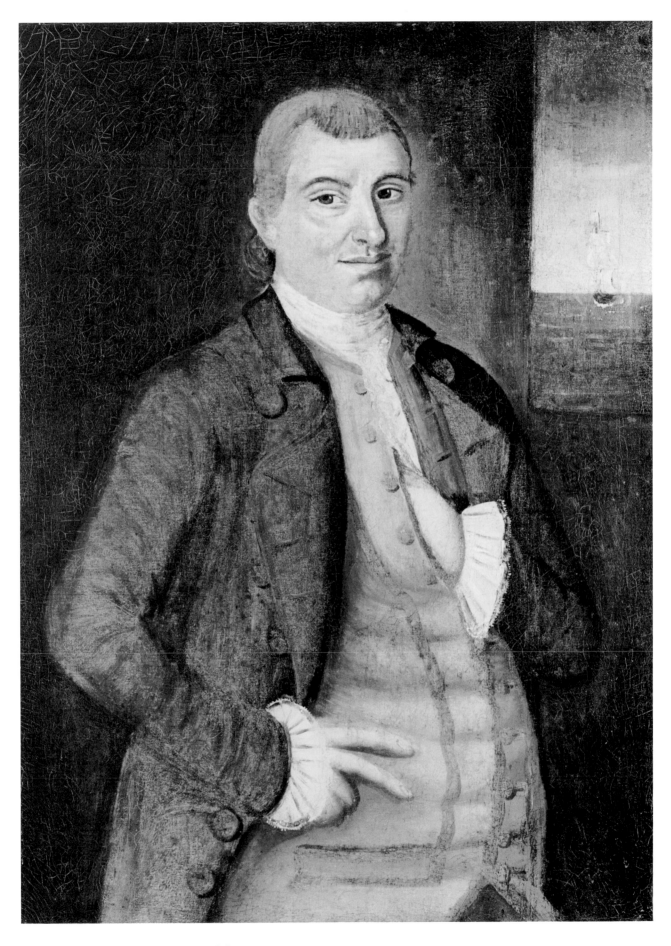

53 BENJAMIN BLYTH. *Benjamin Moses*

Benjamin Blyth (bapt. 1746)

17 *Mrs. Benjamin Moses*
 Oil on canvas, 37 x 27 in.
 Signed at right of chair: "B.Blyth/Pinx 1781"
 Essex Institute, Salem, Massachusetts

 Sarah Carrol (1738-1835) married Benjamin Moses in Salem in 1761. In the paint-
 ing she wears a low-cut gown with gold beads and a close-fitting cap fashionable in
 the early 1780's. Her ninth child, Betsey, born on December 1, 1780, sits on her lap
 clasping a silver and coral whistle. This was always the favorite pose for a mother
 and child.

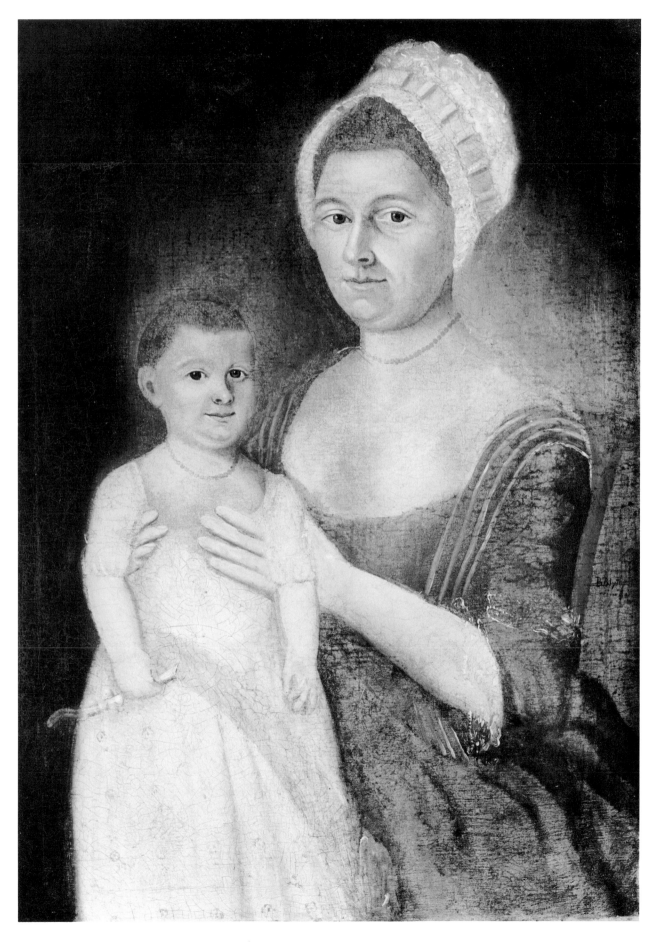

55 BENJAMIN BLYTH. *Mrs. Benjamin Moses*

John Brewster, Jr. (1766-1854)

18 *Dr. and Mrs. John Brewster*
 Oil on canvas, 49⅝ x 40½ in.
 Old Sturbridge Village, Sturbridge, Massachusetts

Dr. Brewster (1739-1823) was the father of the artist and a well-known physician of Hampton, Connecticut. He married his second wife, Ruth Avery (1754-1823) of Brooklyn, Connecticut, in 1789. Several unsigned pictures painted before 1800 may be confidently attributed to John Brewster, Jr., and this double portrait appears to be one of the earliest. It was an ambitious effort for an inexperienced hand; Brewster overcame difficulties in spatial relationships and managed to create a striking three-part composition with the window-view effectively separating the two dominant figures. The back of the imported canvas bears an excise stamp with the inscription "J. Poole/ High Holbourn/ British Linen."

John Brewster, Jr., was the son of Dr. John and his first wife, Mary (Durkee). Although born a deaf-mute, he was taught at an early age to communicate through writing, and he soon evinced a noticeable aptitude for portraiture. After a short course of study under the Reverend Joseph Steward, he began in the mid-1790's to paint creditable portraits of his Connecticut relatives and neighbors. Following the marriage of his brother Royal Brewster, John moved with him to Buxton, Maine, where between painting trips he was to make his permanent home. He traveled widely and advertised portraits and miniatures in local newspapers throughout eastern New York, Connecticut, and the northern New England states. At the age of fifty-one years he enrolled as a member of the opening class in the Connecticut Asylum for the Deaf and Dumb, established in Hartford in 1817, and remained there for three years, probably to study lip reading and artificial speech.

Brewster painted his subjects with extraordinary sensitivity; their features are as clear, tranquil, and precise as a beautifully rendered miniature. One feels that because of his deafness and inability to speak, he was peculiarly alone with his sitters and that this compelling personal relationship is communicated through his portraits in a very special way. He died in 1854 and is buried in Tory Hill Cemetery behind the old Congregational Church in Buxton Lower Corners, Maine.

Ref.: Nina Fletcher Little, "John Brewster, Jr., 1766-1854," *Connecticut Historical Society Bulletin* 25, no. 4 (Oct. 1960).

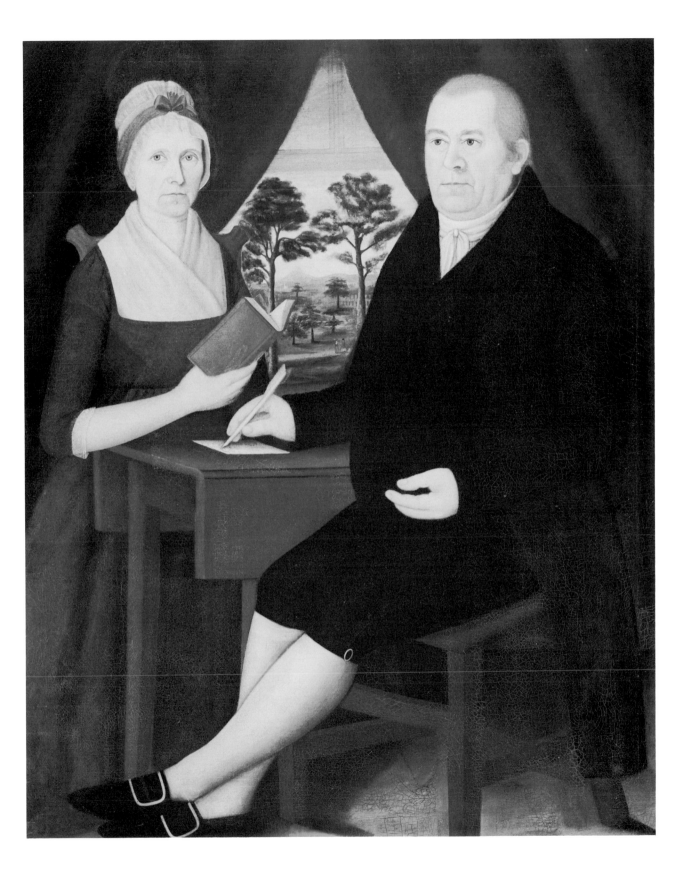

57 JOHN BREWSTER, JR. *Dr. and Mrs. John Brewster*

John Brewster, Jr. (1766-1854)

19 *Captain Daniel Tyler*
 1801, oil on canvas, 36 x 28 in.
 Museum of Fine Arts, Boston

The portrait of Daniel Tyler (1748-1831) of Brooklyn, Connecticut, is identified as to subject, artist, and date by an inscription on the reverse written by his grandson in 1924. Captain Tyler graduated from Harvard College in 1771, served in the Revolution as adjutant to his father-in-law, General Israel Putnam, and saw action in many military campaigns. Prominent later as a businessman and farmer, he was also active in town affairs and is said by his descendants to have walked the ridgepole of the old church on Brooklyn green when he was eighty years old.

After Brewster left Connecticut in the mid-1790's to make his home in Maine, he returned to his native state from time to time. He advertised in 1797 and 1798 in the *Phoenix; or Windham Herald* and the *Chelsea Courier* (Norwich) that he was in Hampton and Chelsea "ready to serve those, in his art, who may furnish him with business." Daniel Tyler's solemn likeness is one of the few portraits known to date from this early Connecticut period.

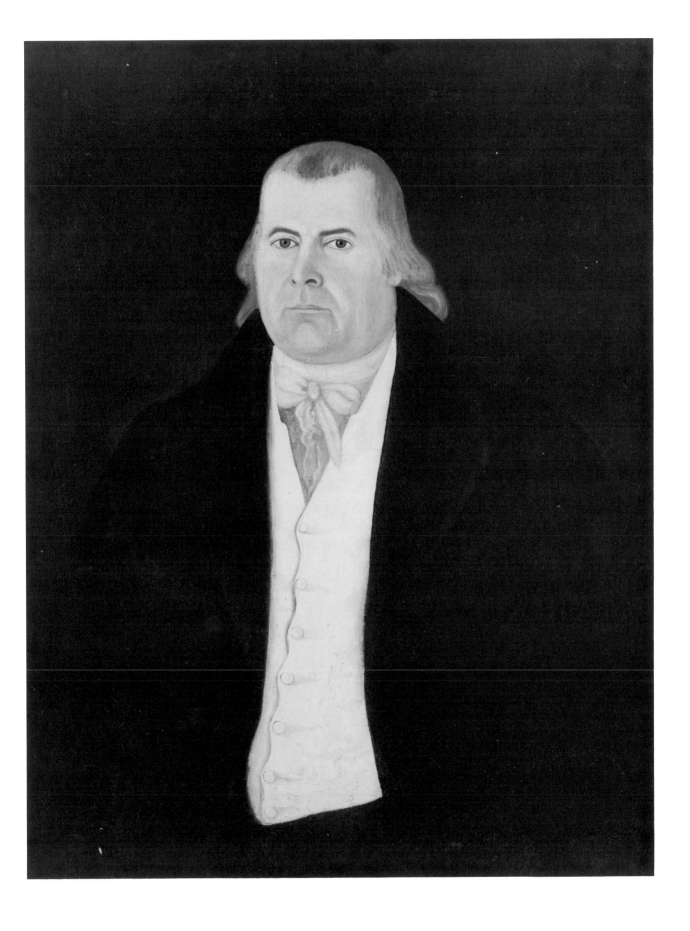

59 JOHN BREWSTER, JR. *Captain Daniel Tyler*

John Brewster, Jr. (1766-1854)

20 *James Prince and Son William*
Oil on canvas, 60⅜ x 60½ in.
Inscription: The letter lying on the desk is inscribed: "Newburyport Novr 24 1801."
Original gold beaded frame
Historical Society of Old Newbury, Newburyport, Massachusetts

James Prince (1755-1830) was a prosperous Newburyport merchant, collector of customs, and warden of St. Paul's Church. Both Washington and Lafayette were entertained in his large, brick residence on State Street. The artist John Brewster, Jr., was also lodged there while he painted at least four imposing portraits of the Prince family in 1801-1802 (including this portrait and no. 21). On January 22, 1802, Brewster advertised in the *Newburyport Herald,* "Portrait and Miniature painter . . . he is at Mr. Prince's where a Speciman of his Painting may be seen . . ." Standing beside Prince is his nine-year-old son, William Henry (1792-1854), who also spent his life in Newburyport.

 The small portable writing desk resting on the table was valued at 50¢ in James Prince's inventory. Behind the table is a tall secretary-desk with large willow brasses, its doors open to reveal two shelves of red-labeled, calf-bound books. In 1830 the bookcase was inventoried at $10.00, the desk at $5.00, and the library of books at $125.00. The floor covering, either woven or painted, is variegated gray and black on a dark brown ground.

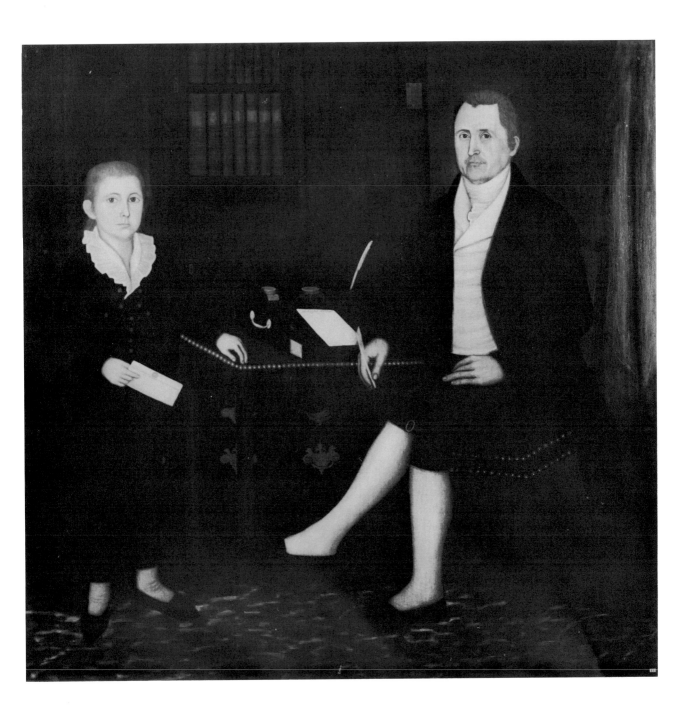

61 JOHN BREWSTER, JR. *James Prince and Son William*

John Brewster, Jr. (1766-1854)

21 *Sarah Prince*
1801-1802, oil on canvas, 52¼ x 39¾ in.
Mrs. Jacob M. Kaplan

Sarah Prince, eldest daughter of James and Mary (Ladd) Prince of Newburyport,
Massachusetts, was probably born there between 1783 and 1787. The portrait is
one of four Prince family pictures (see no. 20) painted when Brewster was staying at
her father's home, as stated in his advertisements that appeared in the *Newburyport
Herald* on December 25, 1801, and January 22, 1802.

Sarah sits beside the piano attired in a long, white dress and holding a sheet of
music in her right hand. Entitled "The Silver Moon," the song was composed in
Scotland by James Hook, and six editions were published in the United States be-
tween 1795 and 1800. This appears to have been a manuscript copy of the printed
score perhaps transcribed by Sarah herself. The clarity and simplicity of this grace-
ful composition illustrate the subtle qualities that are typical of Brewster's early
work.

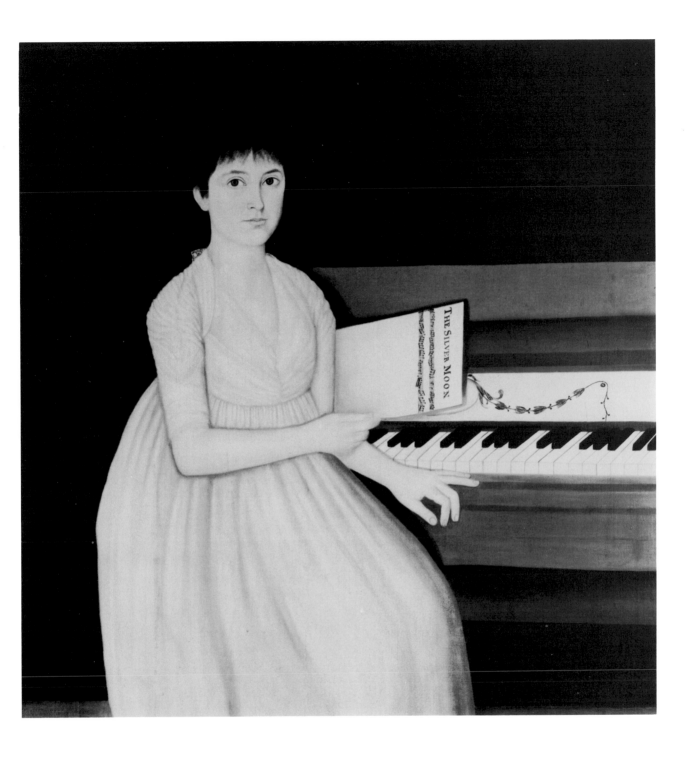

63 JOHN BREWSTER, JR. *Sarah Prince*

Richard Brunton (d. 1832)

22 *Major Reuben Humphreys*
Oil on canvas, 44½ x 40½ in.
Original black, green, and gold painted frame
The Connecticut Historical Society, Hartford

Reuben Humphreys (1757-1832) was born in West Simsbury, Connecticut, served
as a private in the Revolution, and took part in the Battle of Long Island. He even-
tually rose to the rank of brigade major in the state militia and in 1796 was ap-
pointed to the position of superintendent of Newgate Prison, where he remained
until 1801. Thereafter, he removed with his family to New York State, where he
died in Marcellus after almost a whole life devoted to public service. Newgate
Prison, located in East Granby, Connecticut, was erected above a shaft where cop-
per had been mined by the earliest chartered mining company in America. In this
first Connecticut state prison the underground mine tunnels were used as prisoners'
sleeping quarters for more than fifty years. Life at Newgate was harsh, attempted
escapes were frequent, and it became a dreaded place of incarceration.

The date and place of Richard Brunton's birth are uncertain, but it seems prob-
able that he was an Englishman, possibly a deserter from the British army. He was
an itinerant engraver, described as a "transient person," who, in the manner of the
times, turned his hand to many facets of his trade. His best-known work includes
engraved bookplates, some having coats-of-arms, silver ornaments or "love
tokens," printed family record charts, and a now famous view of old Newgate
Prison. A few examples of his work are signed with his name or the initials "RB."
One of the earliest references to him occurs in the Providence *American Journal
and Daily Advertiser,* where he advertised as an engraver and dye sinker in January
1781. Unfortunately Brunton strayed from the paths of virtue and was apprehended
on three different occasions between 1791 and 1799, the last time being remanded
for two years to Newgate Prison for making tools to counterfeit silver coinage. His
model conduct while there, however, gained him the approbation of Superinten-
dent Humphreys, and for Humphreys and various members of his family, Brunton
produced eight different pieces of engraved work in addition to painting likenesses
of the superintendent and his wife. These portraits are Brunton's only known can-
vases in oil and betray a bold but inexperienced hand.

The impressive picture of Humphreys, with conventional window view and un-
usual hanging coat-of-arms, duplicates a small, engraved bust of him that is signed
with Brunton's initials. The largest volume on the table is the 1797 edition of *The
History of Connecticut* (a copy of which is owned by the Connecticut Historical
Society). The portraits were drastically up-dated many years ago to depict the sit-
ters as they looked in later life but have now been restored to their original appear-
ance.

Refs.: Frederick Humphreys, M.D., *The Humphreys Family in America* (New York, 1883),
pp. 389-391; Albert C. Bates, *An Early Connecticut Engraver and His Work* (Hartford,
1906); William L. Warren, "Richard Brunton, Itinerant Craftsman," *Art in America* 39,
no. 2 (April 1951), 81-94.

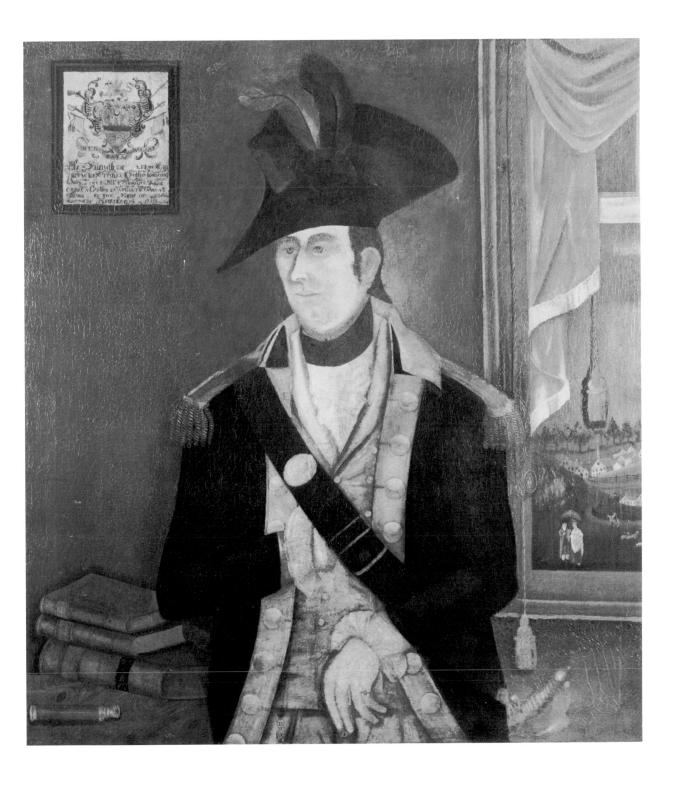

65 RICHARD BRUNTON. *Major Reuben Humphreys*

Richard Brunton (d. 1832)

23 *Mrs. Reuben Humphreys*
Oil on canvas, 44½ x 40½ in.
Original black, green, and gold painted frame
The Connecticut Historical Society, Hartford

Anna (Humphrey) Humphreys (1758-1827) was the daughter of Ezekiel and Elizabeth (Pettibone) Humphrey. She lived with her husband, the superintendent of Newgate Prison, in West Simsbury (later Canton), Connecticut, and became the mother of twelve children. About 1803 she moved with her family to Marcellus, New York, where she died in 1827.

 Mrs. Humphreys is depicted with her infant daughter Eliza in her lap, seated in a Windsor chair and attired in a green gown and stylish plumed hat. Eliza was born in Canton on July 27, 1799. The Chippendale looking glass is painted with an interesting shadow effect and is supported on Battersea enamel knobs. The china tea equipage set on a flowered table covering is another unusual feature of this striking picture.

See also colorplate, p. 8.

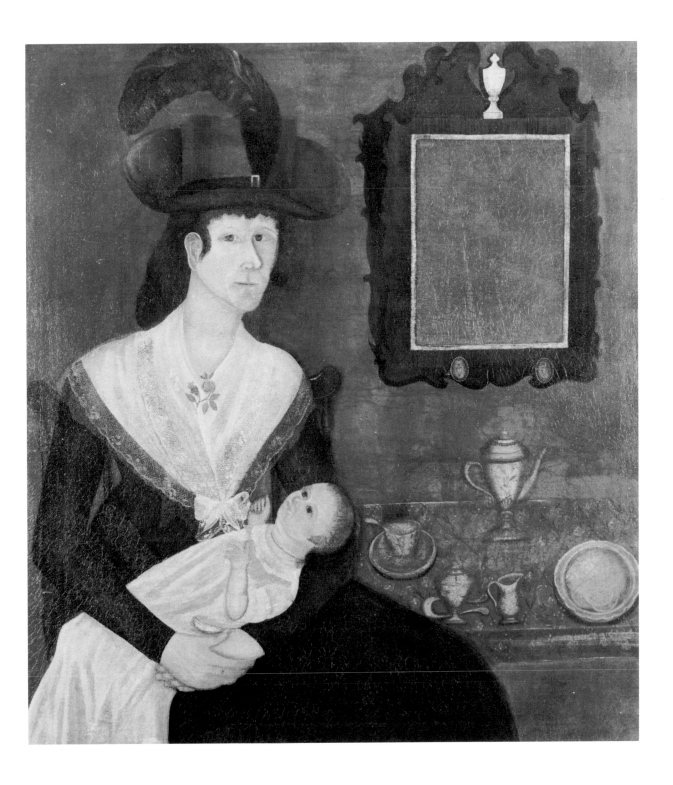

67 RICHARD BRUNTON. *Mrs. Reuben Humphreys*

J. Budington (1779-1823?)

24 *Man with Cane* (John Nichols)
 Oil on canvas, 38¼ x 30½ in.
 Signed on front at lower left: "J. Budington/ Pinxt. 1802"
 The Connecticut Historical Society, Hartford

This picture and its companion, *Woman with Spectacles,* were found in the attic of the old Loomis homestead in Windsor, Connecticut. They had previously been damaged by fire, and the identity of the subjects was then unknown. Recently, however, they have been recognized as careful copies (with one exception) of portraits by Ralph Earl of John Nichols (1754-1817) and his wife of Greenfield Hill, Fairfield, Connecticut (nos. 39, 40). The Earl portraits are signed and dated 1795. It may be assumed that Budington painted the same sitters after an interval of seven years to the order of a member of the Nichols family.

 J. Budington is presently known through some six signed portraits, presumably of Connecticut origin, and one waterfront view of Cannon Wharf, New York City, signed and dated 1792. One Jonathan Budington, son of Edward, was born in Fairfield in 1799, married Sarah Peck in New Haven in 1820, and died there in 1823. This man was probably the artist, but the name Jonathan Budington appears elsewhere in genealogical records with conflicting and confusing places and dates. William Dunlap in his *History of the Rise and Progress of the Arts of Design* wrote in 1834: "Buddington painted portraits in New York, 1798." His name, listed as "portrait painter" also appeared in the New York City directories from 1800 through 1804 and again from 1809 to 1812. As in the work of other provincial artists, the competence of Budington's style varies considerably. Although his sitters usually appear relaxed, and several are posed against the conventional draperies or window views of their period, one would like to see more of his portraits and landscapes before assessing the overall quality of his work.

Ref.: Nina Fletcher Little, "Little-Known Connecticut Artists, 1790-1810," *Connecticut Historical Society Bulletin* 22, no. 4 (Oct. 1957), 98.

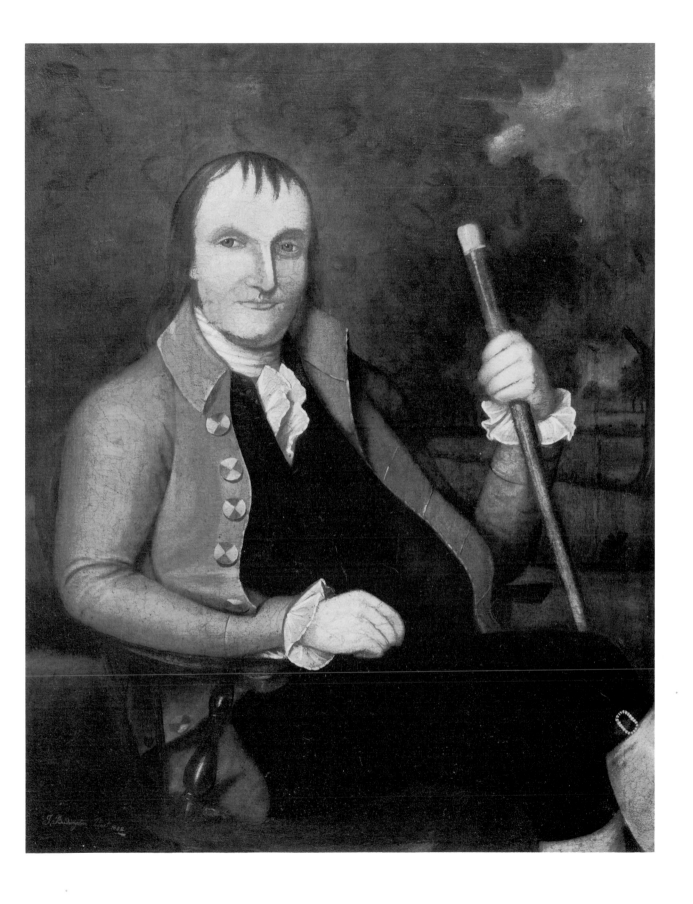

69 J. BUDINGTON. *Man with Cane*

J. Budington (1779-1823?)

25
Woman with Spectacles (Mrs. John Nichols)
Oil on canvas, 38½ x 30½ in.
Signed on window sill at left: "J. Budington Pinxt. 1802"
The Connecticut Historical Society, Hartford

The portrait was found stored away in the old Loomis house in Windsor, Connecticut. Like her husband's picture, *Woman with Spectacles* is practically a duplicate of Ralph Earl's *Mrs. John Nichols* (no. 40), with one important exception. Whereas Earl's *Mrs. Nichols* holds her infant daughter Charlotte in her lap, the Budington copy omits the child and substitutes a pair of spectacles held in the sitter's hand. It is obvious that, with the difference of seven years between the Earl and Budington portraits, Charlotte would no longer have been a baby in 1802.

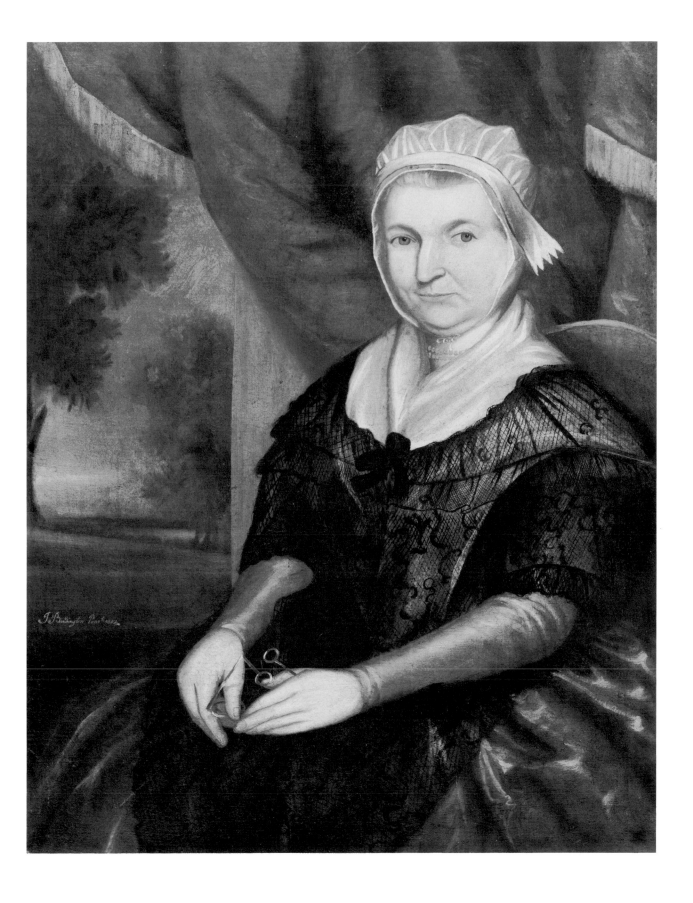

71 J. Budington. *Woman with Spectacles*

J. Budington (1779-1823?)

26 *Little Girl with Kitten*
 Oil on canvas, 31 x 28 in.
 Signed at left of foot: "J. Budington Pinxt 1800"
 Mr. and Mrs. Bertram K. Little

Seated in a child-size, hoop-back Windsor chair, this unknown little girl makes an
endearing subject for Budington's painting. The dark-patterned wallpaper behind
her provides a pleasing foil for the two-toned blue woodwork and emphasizes the
importance of the little figure in her white gown and red slippers. An open doorway
balances the composition, and the white balustrade beyond is an effective device to
give perspective to the landscape and distant cottage.

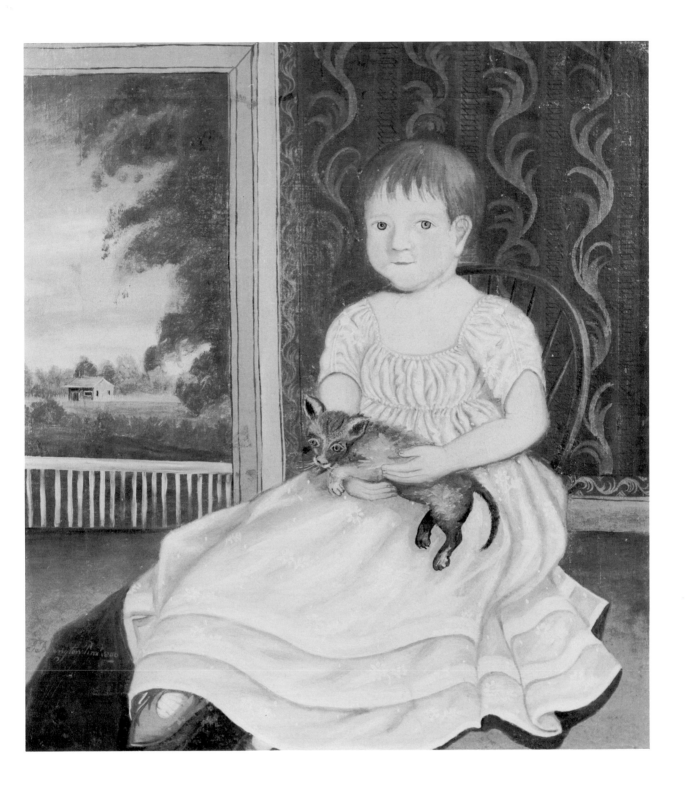

73 J. Budington. *Little Girl with Kitten*

Winthrop Chandler (1747-1790)

27 *Mrs. Ebenezer Devotion*
 Oil on canvas, 53 x 43 in.
 Inscribed on reverse: "Martha Devotion Born March 28th, 1716,
 O.S. Drawn May 8th, 1770. N.S."
 Original black-painted frame
 Brookline Historical Society, Brookline, Massachusetts

Martha (Lathrop) Devotion (1716-1795) was born in Norwich, Connecticut, daughter of Colonel Simon and Martha (Lathrop) Lathrop, and sister of Rufus Lathrop (no. 37). She was first married to the Reverend Ebenezer Devotion and after his death became the wife of the Reverend James Cogswell, his successor at the Scotland, Connecticut, church. Likenesses of three generations of the Devotion family were painted in Scotland before 1772. The portraits, including this one, were enumerated in the will of Ebenezer Devotion, Jr., in 1829 as "the seven family pictures painted by Chandler." They are considered, therefore, the key pictures on which rest the attributions of other examples of Chandler's work.

Winthrop Chandler was a house and general fancy painter, and he also painted a number of overmantel landscapes, but about fifty remarkable portraits attest to his ability as a limner. The son of William and Jemima (Bradbury) Chandler, he was born and lived in Woodstock, Connecticut, but spent the last five years of his life in Worcester, Massachusetts. There, in 1788, he gilded the Court House weathervane "laying on of 8 books of gold leaf at 2 shillings per book." He also carved and painted a fine rendering of the British coat-of-arms for his cousin Gardiner Chandler. Throughout his life he suffered from financial embarrassment, and his pictures, all painted for family, neighbors, or friends, were an attempt to augment his meager substance. Eight weeks before his death in Thompson, Connecticut, he executed a pathetic quit-claim deed in which all his personal property was left to the local Selectmen in full compensation for the town's future expenses in caring for him in his last illness and burial.

It is ironic, therefore, that Chandler is now considered to be one of the most important provincial artists of the Revolutionary period. Despite its somber, linear quality, his portrait of Martha Devotion is monumental in its stark realism, and impressive in its fine, structural design.

Refs.: Nina Fletcher Little, "Winthrop Chandler," (Catalogue of an exhibition held at the Worcester Art Museum, April-May 1947); *Art in America* 35, no. 2 (April 1947); idem, "Recently Discovered Paintings by Winthrop Chandler," *Art in America* 36, no. 2 (April, 1948), 81-89.

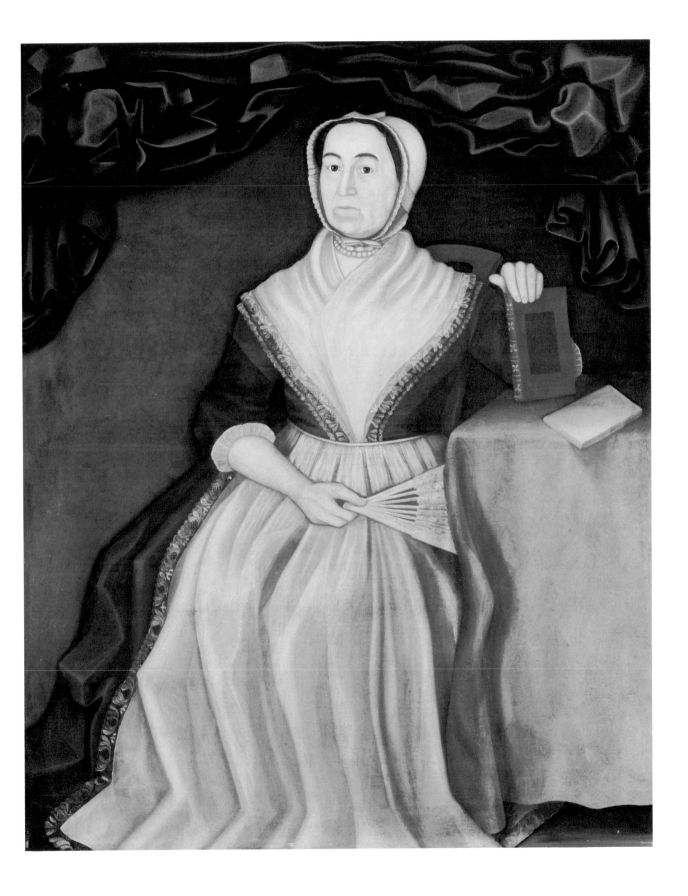

75 WINTHROP CHANDLER. *Mrs. Ebenezer Devotion*

Winthrop Chandler (1747-1790)

28 *Homestead of General Timothy Ruggles,* Hardwick, Massachusetts
Oil on canvas, 31 ½ x 62 ½ in.
Original black frame
Miss Julia T. Green

Timothy Ruggles (1711-1792), whose homestead this picture traditionally repre-
sents, was the father-in-law of Gardiner Chandler of Worcester, a first cousin of the
artist. In 1753, previous to an impressive military career, which included serving in
the Seven Years War and in the expedition against Crown Point under Sir William
Johnson, Ruggles had moved to Hardwick, Massachusetts. He later held many high
offices in the Colonial government and commanded the Gentlemen Volunteers, a
Boston loyalist group. As a Tory, he was forced to take refuge with the British in
1775 and ended his days on a Crown grant near Annapolis, Nova Scotia. After con-
fiscation of his Hardwick estate, a vendue was advertised in the *Massachusetts Spy,*
or American Oracle of Liberty, on January 16, 1776. Only the cellar hole of the
Ruggles home (at left) is visible today, but several features of the original landscape
are still recognizable. Although artistic license was apparently taken in painting the
house and surrounding terrain, the old well stone, initialed "T R" and dated 1759,
was discovered some years ago in the location shown here behind the house.

Chandler's other known landscapes were painted on wooden chimney breasts.
His buildings were always carefully drawn with a house painter's eye for detail.
The picturesque trees are a recurring feature of his work, while the hare and hounds
at left and the distant horsemen echo elements found in imported engravings of the
period. In the 1799 inventory of Ruggles' son-in-law, Dr. John Green of Worcester,
in whose family the picture descended, occurs the following entry which may well
refer to this painting: "1 large landscape, 33¢."

See also colorplate, p. 10.

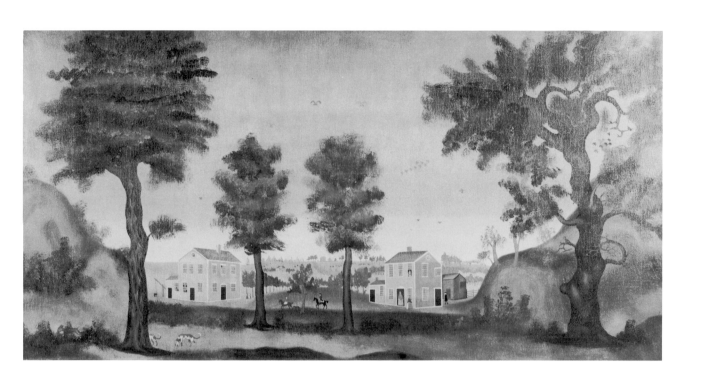

77　WINTHROP CHANDLER. *Homestead of General Timothy Ruggles*

Winthrop Chandler (1747-1790)

29 *Captain Samuel Chandler*
 Oil on canvas, 54⅞ x 47⅞ in.
 National Gallery of Art, Washington, D.C.
 Gift of Edgar William and Bernice Chrysler Garbisch

Samuel Chandler (1735-1790), an elder brother of the artist, was born in Wood-
stock, Connecticut. During the Revolution he kept a tavern near the present town
of Fabyan. As captain of the 11th Company, 11th Regiment of Connecticut Militia,
he marched to West Chester in 1776, and he is depicted here in his blue uniform
with gold epaulettes. The silver-hilted sword was listed in his inventory at a value
of 36 shillings. The explicitly drawn battle scene obviously commemorated
Chandler's military service, but if it represented an actual episode, the exact locale
has not been identified. Following the Revolution in 1780, he became a member of
the Connecticut legislature.

 The full-length figures of Captain and Mrs. Chandler are painted with the stark
realism typical of Winthrop Chandler's work. The portraits are enumerated in
Samuel Chandler's inventory as "2 effigies or likenesses, 6 pounds."

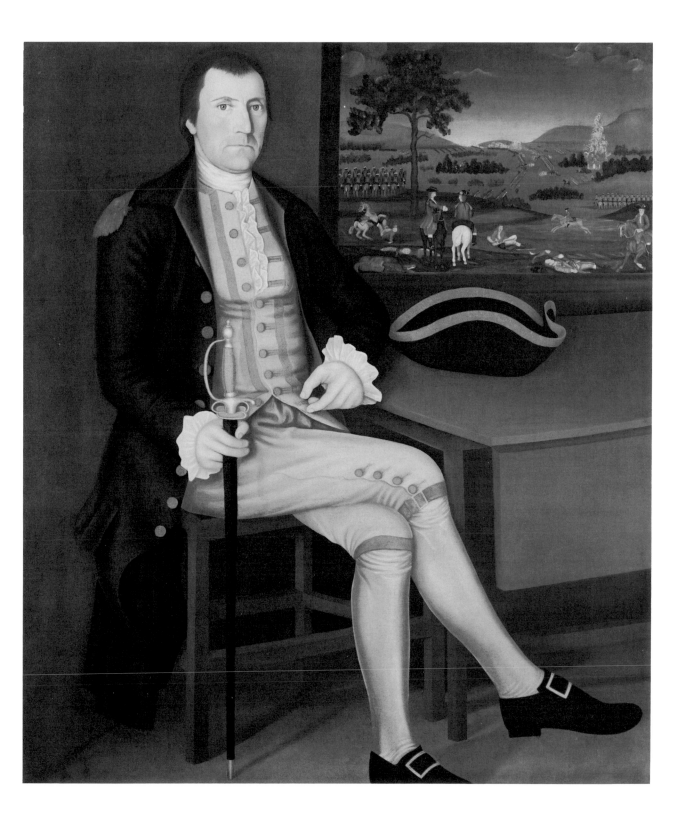

79 WINTHROP CHANDLER. *Captain Samuel Chandler*

Winthrop Chandler (1747-1790)

30 *Mrs. Samuel Chandler*
Oil on canvas, 54¾ x 47⅞ in.
National Gallery of Art, Washington, D.C.
Gift of Edgar William and Bernice Chrysler Garbisch

Anna (Paine) Chandler (1738-1811) was born in South Woodstock, Connecticut, the daughter of Daniel and Leah (Smith) Paine. She married Samuel Chandler on July 17, 1760, and following his death in 1790 became the wife of the Reverend Josiah Whitney, pastor for sixty years of the Congregational Church in Brooklyn, Connecticut.

 This is one of Chandler's most sensitive and penetrating characterizations. The voluminous drapery is an artistic convention, but the tripod table and books were actual family possessions, inventoried at 12 shillings and 2 pounds respectively.

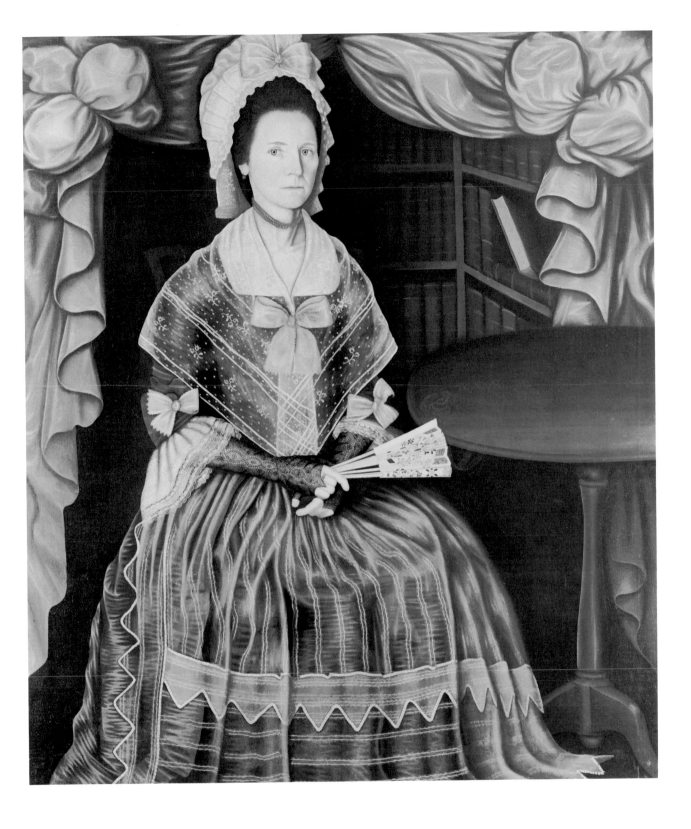

81 WINTHROP CHANDLER. *Mrs. Samuel Chandler*

Winthrop Chandler (1747-1790)

31 *Shelf of Books* (overmantel panel)
Oil on wood, 27 x 58 in.
Shelburne Museum, Shelburne, Vermont

This unusual composition formed part of the original chimney breast of the lower southeast room in the house of General Samuel McClellan built in South Wood-stock, Connecticut, in 1761 and long known as the Arnold Inn. Samuel McClellan was a brother-in-law of Winthrop Chandler, who also painted handsome likenesses of the McClellans and their daughter Mary. The bookshelves, with their scalloped partitions, were cleverly painted in the center of an overmantel panel to simulate an actual chimney cupboard of the type sometimes seen above eighteenth century fireplaces.

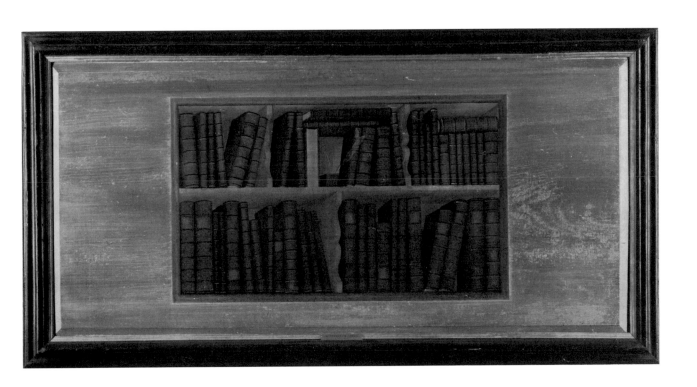

83 WINTHROP CHANDLER. *Shelf of Books*

Michele Felice Cornè (1752-1838)

32
Ezekiel Hersey Derby Farm, South Salem, Massachusetts
Oil on canvas, 40½ x 53½ in.
Mr. and Mrs. Bertram K. Little

This eighteenth century farm was purchased early in 1800 by Ezekiel Hersey Derby, son of Salem's prominent merchant Elias Haskett Derby. Soon thereafter, Samuel McIntire was engaged to embellish the house and barn. The carved swag on the barn at right and the summer house on the opposite hill were McIntire's designs. Derby, accompanied by his family and friends, often drove out by coach to his country estate, situated at what is now the corner of Lafayette Street and Ocean Avenue, although it was only a mile and a half from his Salem residence. The Derby family coach is seen in the foreground, while two figures behind the stone wall may well represent McIntire, the architect, with rolls of plans in hand and Cornè, the artist, drawing in a sketchbook on his knee.

Cornè, a picturesque and spicy character, was born on the island of Elba in 1752. He came from Italy to make Salem his home in 1799, traveling on the Derby-owned ship *Mount Vernon.* A versatile ornamental painter, he enlivened the households of his adopted town with colorful portraits of local citizens and their vessels, romantic landscapes on overmantels and fireboards, and wall frescoes and scenic panoramas. After departing from Salem about 1807, Cornè located in Boston, where he appears to have frescoed a room in the first Harrison Gray Otis house before moving to Newport, Rhode Island, in 1822. There he is said to have introduced the tomato as an edible food before his death at the ripe old age of eighty years. Cornè's painting had the style and flair of a Mediterranean port artist, and his many talents contributed a unique quality to New England provincial art.

Ref.: Philip Chadwick Foster Smith and Nina Fletcher Little, *Michele Felice Cornè* [exhibition catalogue] Salem, Mass.: Peabody Museum, summer 1972.

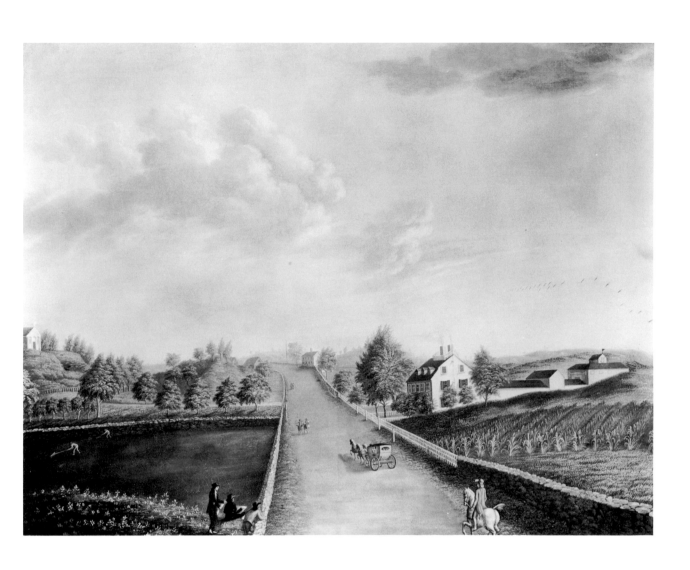

85 MICHELE FELICE CORNÈ. *Ezekiel Hersey Derby Farm*

Abraham Delanoy (1742-1795)

33 *Mrs. John Sherman*
Oil on canvas, 45¾ x 41¾ in.
Ebonized and gilt frame perhaps original
Miss Mary B. Palmer

Rebecca (Austin) Sherman (1753-1830) sits with her son Henry, born in 1785, on her lap. She was the first wife of Captain John Sherman of New Haven, Connecticut, where she kept boarders and raised a large family. Claiming that her husband was a violent drinker, Mrs. Sherman divorced him in 1793, and during the unpleasantness that followed, her portrait was slashed as it appears today.

Abraham Delanoy was born in New York City in 1742, studied with Benjamin West in London about 1766, and advertised portrait painting in Charleston, South Carolina, in November 1768. On January 7, 1771, his second advertisement for portrait painting appeared in the *New-York Gazette and the Weekly Mercury*. It is known that four years previously, he had painted four members of the Beekman family, the forthright likeness of William Beekman being signed and dated 1767. By 1784 Delanoy had taken up residence in New Haven, where he advertised in the *Connecticut Journal* in June of that year and again in 1785 and 1786. He then offered, in addition to portraits, the painting of carriages, houses, signs, and ships at low prices, and he also dealt in all sorts of artists' supplies. In 1786 he drew a pastel profile of Mrs. Simeon Jocelyn (now in the collection of the Connecticut Historical Society), the authorship of which is documented by a nineteenth century label. During this or the following year he produced likenesses of Mrs. John Sherman and family, and an old photograph of the original canvas of John Sherman, Jr., before restoration shows the inscription "A. Delanoy Pinxit." The portrait of John's brother, David A. Sherman, is dated "Jan. 2d 1787." Apparently not meeting with hoped-for success, Delanoy sold his shop and left New Haven shortly after 1787, and in 1790 he settled with his large family in Mount Pleasant Town, Westchester County, New York, where he died on January 23, 1795.

Attribution of Delanoy's little-known portraits rests at present on only a few signed or documented examples. Facial features, hairstyle, and accessories in the latter bear a strong resemblance to those in the Jocelyn pastel profile and the more ambitious, three-quarter-length oil of Mrs. Sherman. Stiffer in pose, and obviously less competent than his earlier New York group, Delanoy's New Haven pictures apparently signaled the close of a peripatetic and not too successful career. William Dunlap remembered him in the early 1790's as "consumptive, poor and his only employment sign-painting." Delanoy deserves recognition, however, as an aspiring provincial artist, briefly trained in London, who never achieved eminence at the top of his profession but, nevertheless, added his bit to the sum of American indigenous art of the Revolutionary period.

Refs.: Susan Sawitzky, "Abraham Delanoy in New Haven," *The New-York Historical Society Quarterly* 41, no. 2 (April 1957), 193-206; Christine Skeeles Schloss, *The Beardsley Limner and Some Contemporaries,* [exhibition catalogue], (Williamsburg, Va.: the Abby Aldrich Rockefeller Folk Art Collection, 1972), 47; William L. Warren, "Connecticut Pastels, 1775-1820," *Connecticut Historical Society Bulletin* 24, no. 4 (Oct. 1959), 100, 101, 115.

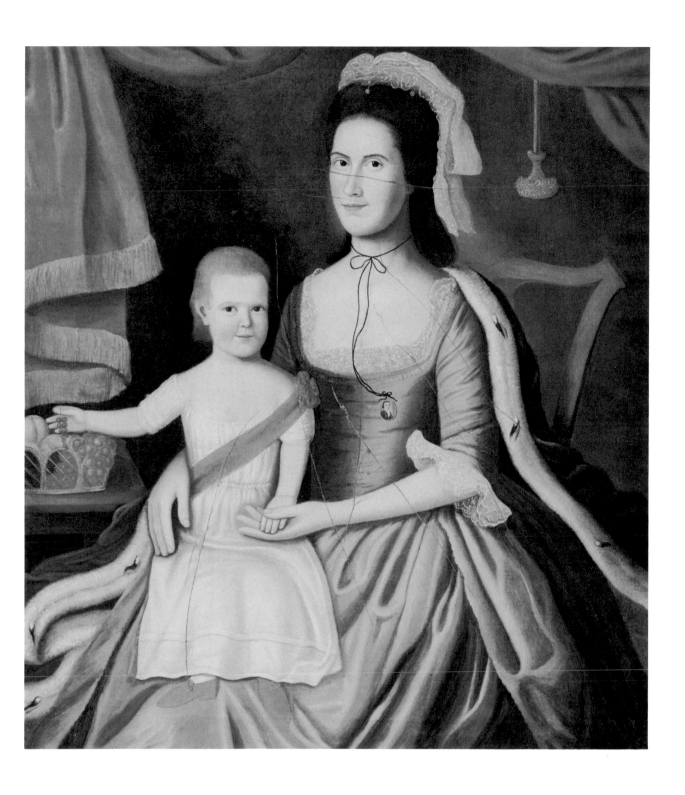

87 ABRAHAM DELANOY. *Mrs. John Sherman*

Denison Limner (active late 18th century)

34 *Elisha Denison*
Oil on canvas 34½ x 27½ in.
Boy holds card in hand with his father's name: "Capt. Elisha Denison.
Stonington."
Original black and gold frame
Descendants of Elisha Denison

Elisha Denson (1779-1803) was the son of Captain Elisha and Elizabeth (Noyes) Denison of Stonington, Connecticut. He died at the early age of twenty-four years, and it is surmised that he perished at sea.

 The anonymous artist referred to as the "Denison Limner" is so designated because seven known portraits of the Denison family all appear to have been painted by the same hand. Several other comparable portraits may also be ascribed to him.

 Standing within an arch that rests on the tops of molded columns, Elisha is elegantly clad in red coat with pewter buttons, blue trousers, and vest, whose brilliant colors are complimented by a bright landscape view in the background. The composition is further enriched by the addition of the end of a yellow building artfully introduced at the left. The artist's extraordinary flair for decorative design has resulted in a striking picture in which the individual personality is submerged in an arrestingly colorful linear pattern.

Ref.: Mary Black and Jean Lipman, *American Folk Painting*, (New York: Clarkson N. Potter, 1966), figs. 26-31.

See also colorplate, p. 12.

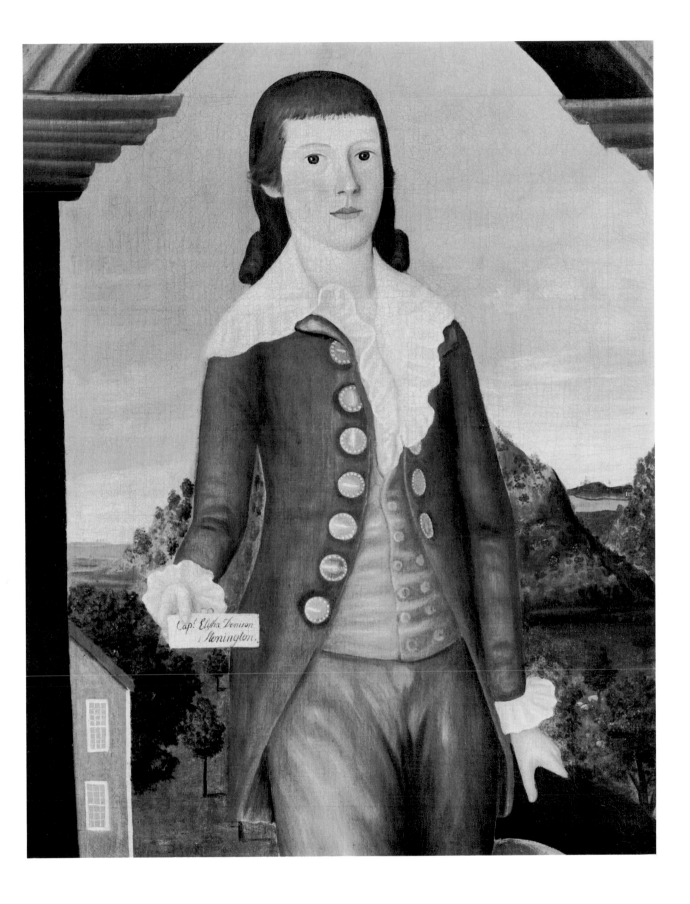

89 DENISON LIMNER. *Elisha Denison*

Denison Limner (active late 18th century)

35 *Lady with Plumed Headdress*
 Oil on canvas, 33⅝ x 26⅝ in.
 National Gallery of Art, Washington, D.C.
 Gift of Edgar William and Bernice Chrysler Garbisch

This picture is one of seven Denison family portraits attributed to the same uniden-
tified hand. The history of previous ownership suggests that the subject was
Elizabeth Denison (1773-1849) daughter of Captain Elisha and Elizabeth (Noyes)
Denison of Stonington, Connecticut, and an elder sister of Elisha Denison (no. 34).
She married Nathaniel Ledyard in 1793, and they had nine children.

 Seated erect in a country Chippendale side chair and wearing a stylish red gown,
Elizabeth displays the long curls and elaborate feather headdress so fashionable in
the mid-1790's. Her left arm rests on the edge of a small, draped dressing table.
As is the case in her brother's portrait, one is immediately conscious of the artist's
preoccupation with color and design.

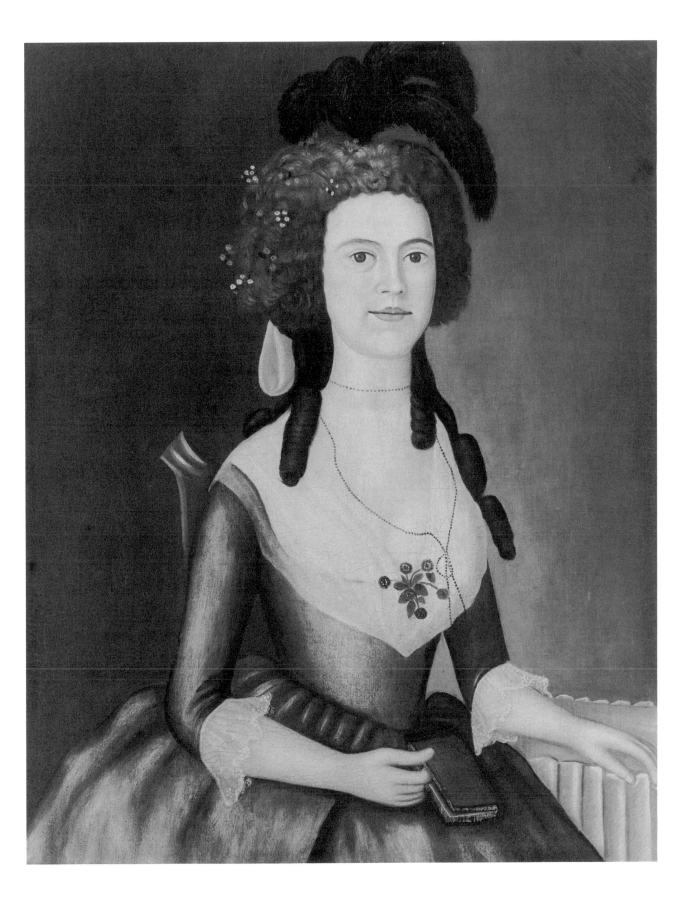

91 DENISON LIMNER. *Lady with Plumed Headdress*

John Durand (active 1768-1780's)

36 *Benjamin Douglas*
 Oil on canvas, 30 x 26 in.
 Signed on reverse before relining: "Benjamin Douglas/ aged 33 A.D.
 1772/ "J. Durand AD Vivam Pinxt."
 Black and gold frame probably original
 New Haven Colony Historical Society, New Haven, Connecticut

Benjamin Douglas (1739-1775) was born in Plainfield, Connecticut, son of Colonel John and Olive (Spaulding) Douglas. He was educated at Yale College, graduated in 1760, and settled in New Haven. After admittance to the Connecticut bar, he became King's Attorney for the County and enjoyed a brief but brilliant career.

John Durand is recognized as one of the most stylish painters working in Connecticut and elsewhere during the Revolutionary period, but scant personal information concerning him is available. Said to have been a descendant of the French Huguenot settler Jean Durand of Connecticut, the artist is first heard of in New York City, where a long notice advertising his work appeared in *The New-York Gazette or the Weekly Post-Boy* on April 11, 1768. Though admitting to some lack of knowledge in the arts of "Perspective, Anatomy, and Expression," he aspired to follow the newly fashionable branch of history painting. In this he was apparently not successful, as it is his outstanding portraits for which he is now remembered. According to information published by William Dunlap in 1834, Durand "painted an immense number of portraits in Virginia . . . that appear to have been strong likenesses." Pictures of two members of the Newton family were found many years ago in Richmond, signed and dated 1770, the same year that he advertised on June 7th in the *Virginia Gazette:* "Gentlemen and Ladies that are inclined to have their pictures drawn will find the subscriber ready to serve them, upon very reasonable terms . . . Williamsburg, June 7, 1770."

Durand was an itinerant, and his travels eventually took him to New England, where a small group of portraits was commissioned in New Haven and Norwich during the early 1770's. By the time these Connecticut pictures were painted, his style had matured and softened noticeably in contrast to that of the hard, brilliant likenesses that are ascribed to him in the earlier New York period. The dates and places of his birth and death have not so far been determined, but he is said to have been painting again in Virginia in the early 1780's.

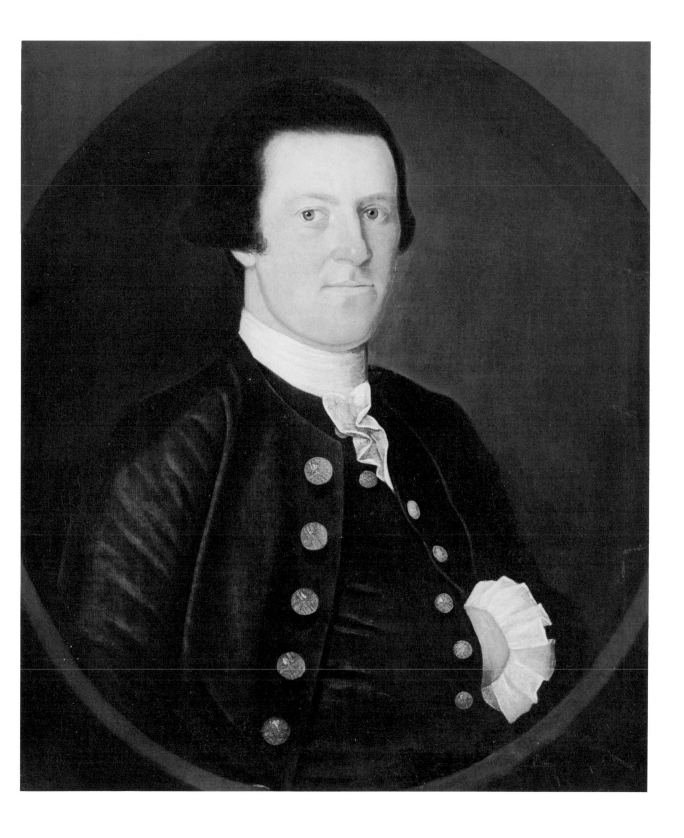

93 JOHN DURAND. *Benjamin Douglas*

John Durand (active 1768-1780's)

37 *Rufus Lathrop*
 Oil on canvas, 48¼ x 36¼ in.
 Mr. and Mrs. Bertram K. Little

Rufus Lathrop (1731-1805), son of Colonel Simon Lathrop of Norwich and
brother of Martha (Lathrop) Devotion (no. 27), was a member by double inheri-
tance of one of Connecticut's most distinguished families. He is thought possibly
to have been a goldsmith at one time, as one David Greenleaf, who later became
a goldsmith, was apprenticed to him. When still a young man, Lathrop traveled
to Ipswich (now Essex), Massachusetts, to visit the well-known clergyman the
Reverend John Cleaveland. While there he met Hannah Choate, who in 1757
became his wife. A strong attachment developed between him and his wife's
Ipswich relatives, and following her death in 1785 he corresponded warmly with
them in a series of letters still preserved with the pictures.

The portraits were painted in Norwich, Connecticut, and were described as
follows by a member of the Choate family who saw them there in the Lathrop
home: "There is a great degree of spirit in both yet mixed with mildness, and they
are represented in all the richness of antique grandeur. They are both in their
"wedding suit." Fine color and great attention to costume detail as seen here have
always been outstanding characteristics of Durand's work.

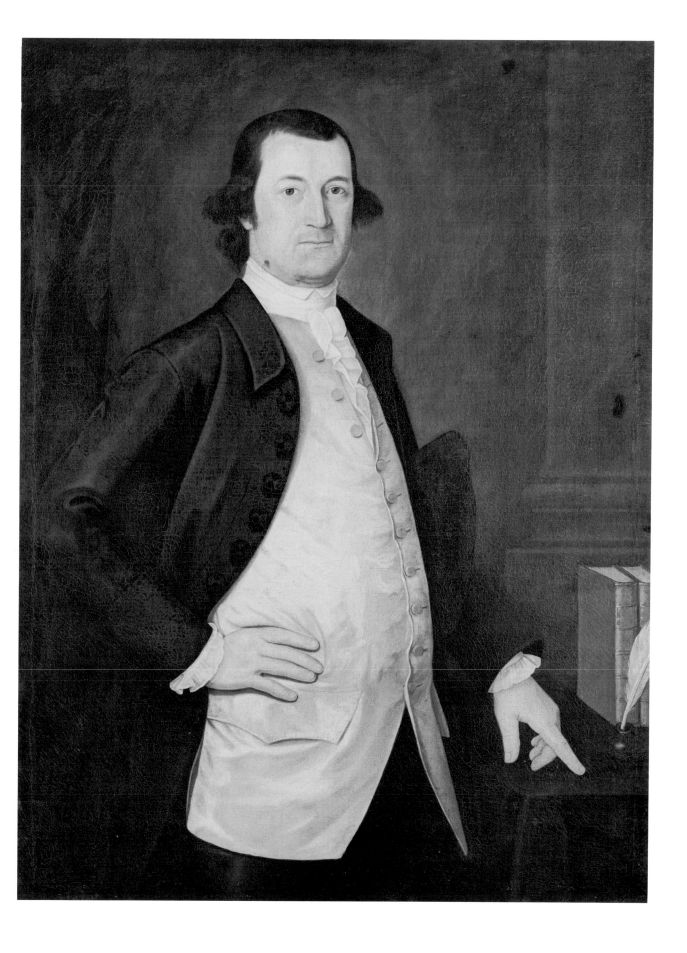

95　John Durand. *Rufus Lathrop*

John Durand (active 1768-1780's)

38 *Mrs. Rufus Lathrop*
 Oil on canvas, 48¼ x 36¼ in.
 Mr. and Mrs. Bertram K. Little

Hannah Choate (1739-1785) was born on Hog Island in Ipswich Bay, Massachusetts, in the house of her father, Francis Choate, which still stands on the island. Soon after her birth, the family moved to a farm on the mainland, and there she met Rufus Lathrop of Norwich, Connecticut, who was brought to tea by the local clergyman, John Cleaveland. Hannah and Rufus were married in 1757 and made their home in Norwich, where their portraits were painted and remained in the family until the late nineteenth century. The pictures were then presented to Choate family descendants in Essex, and were returned to hang in the old Choate house, which stood next to the one in which Hannah had met her husband.

In a letter to the Choates describing this portrait after his wife's death in 1785, Rufus Lathrop wrote: "Her skin is clear and her form and features extremely beautiful. Her countenance is animated yet full of expression, peculiarly dignified and commanding . . . I am proud and gratified to have seen in this picture a good likeness of my wife while in her best health." Other members of the Lathrop family were painted in Norwich by John Durand, all typical of his distinctive Connecticut work.

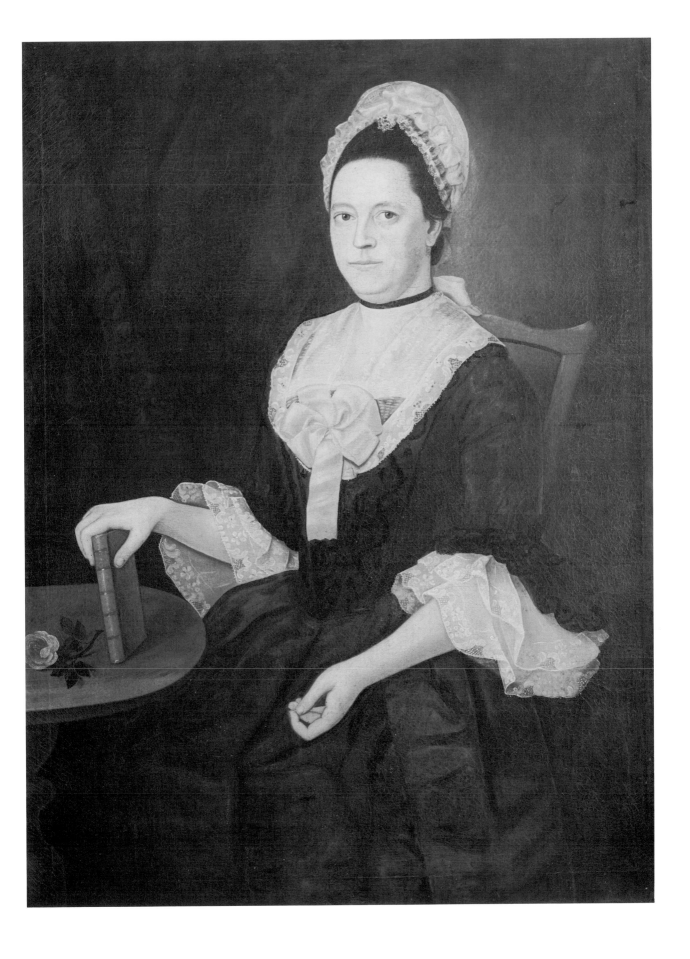

97 JOHN DURAND. *Mrs. Rufus Lathrop*

Ralph Earl (1751-1801)

39 *John Nichols*
 Oil on canvas, 38 x 30½ in.
 Signed in lower left corner: "R. Earl Pinxt 1795."
 Original black-painted frame
 Private Collection

John Nichols (1754-1817), son of Ephram, was born in Greenfield Hill, a part of Fairfield, Connecticut. He married Mary Hill, and they later moved to Easton, about ten miles away, where they both died. In Nichol's will, inventory, and subsequent distribution occurs the mention of meadows, lots, farmlands, and woodland, indicating that he owned considerable property in Easton, some of which he farmed. A blacksmith shop and one-quarter ownership in a saw mill are also enumerated.

Ralph Earl's artistic career was unique in New England after his return from abroad following the Revolution. A son of Ralph and Phoebe (Whittemore) Earle, he grew up in Lancaster, Massachusetts, and in 1774 married his cousin Sarah Gates of Worcester. The young couple set up housekeeping in New Haven, and Earl is credited with portraits of two prominent local citizens and four sketches of the battles of Lexington and Concord engraved by Amos Doolittle in 1775. Because of Loyalist activities, he was forced to leave Connecticut, and forsaking his wife and two children he sailed for England, arriving there in April 1778.

In England Earl met with encouragement and approbation, and his many identified portraits painted there exhibit the characteristics associated with the late eighteenth century academic school. He exhibited at the Royal Academy from 1783 through 1785, but feeling, perhaps, that he could not compete with the acknowledged European masters, he decided to return to America with his second wife. The *Salem Gazette* of Tuesday, May 24, 1785, recorded under the heading of Boston, May 23: "In the Neptune, Capt. Callahan, who arrived here since our last, in 30 days from England . . . Mr. Earl and lady, Worcester." Within six months Earl had made his way to New York City and under the date of November 2, 1785, *The Independent Journal or the Gen. Advertiser* recorded: "Last Sunday arrived in town from England, by way of Boston, Mr. Ralph Earl, a native of Massachusetts: he has passed a number of years in London, under those distinguished and most celebrated masters in Painting, Sir Joshua Reynolds, Mr. West, and Mr. Copley. This gentleman now proposes to enter upon his profession in this city."

Despite a propensity for alcohol and unpaid bills that landed him in the New York City jail, Earl emerged in 1788 to become a successful and sought-after portraitist who traveled throughout Connecticut depicting many of the well-to-do business and civic leaders of the post-Revolutionary period. His work deteriorated sharply during the last two years of his life, but at the height of his career Earl's large and handsome canvases were endowed with elegance and sophistication, derived from his English experience, that were unmatched by his provincial New England contemporaries. He died in Bolton, Massachusetts, at the age of fifty years.

Earl painted several families in Fairfield and Greenfield Hill, and the delightfully relaxed portraits of Mr. and Mrs. Nichols, painted against peaceful landscape backgrounds, typify the domestic tranquility that Earl knew so well how to convey.

Refs.: Laurence B. Goodrich, *Ralph Earl, Recorder for an Era* (Albany: the State University of New York, 1967); William and Susan Sawitzky, "Two Letters from Ralph Earl with Notes on His English Period," Worcester Art Museum, *Annual* 8 (1960), 8-41.

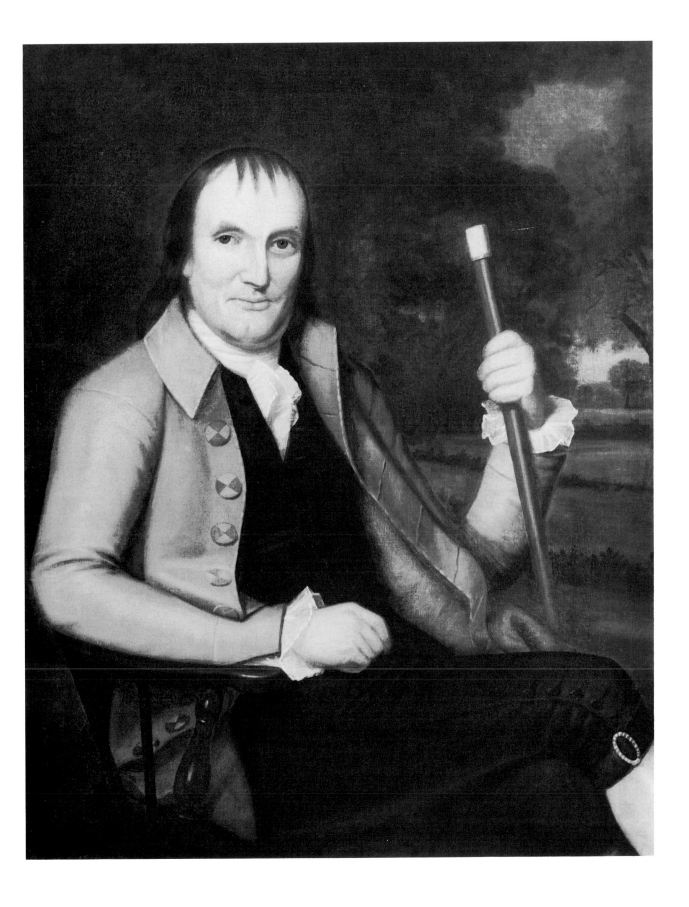

99 RALPH EARL. *John Nichols*

Ralph Earl (1751-1801)

40 *Mrs. John Nichols*
 Oil on canvas, 38 x 30¼ in.
 Signed below window: "R. Earl Pinxt 1795."
 Original black-painted frame
 Private Collection

Mary (Hill) Nichols (ca. 1756-1844) became the mother of twelve children, who are listed in the *History and Genealogy of the Families of Old Fairfield*. Her next to youngest child was a daughter named Charlotte, born in Greenfield Hill on June 7, 1795, and it appears to be the infant Charlotte who is shown in the portrait sitting on her mother's lap. The gold-fringed, red drapery makes a handsome background for mother and child.

Seven years later, in 1802, Jonathan Budington copied Earl's portrait of Mr. and Mrs. Nichols (nos. 24, 25), substituting a pair of spectacles held by Mrs. Nichols for the figure of Charlotte, who by that date was no longer a baby.

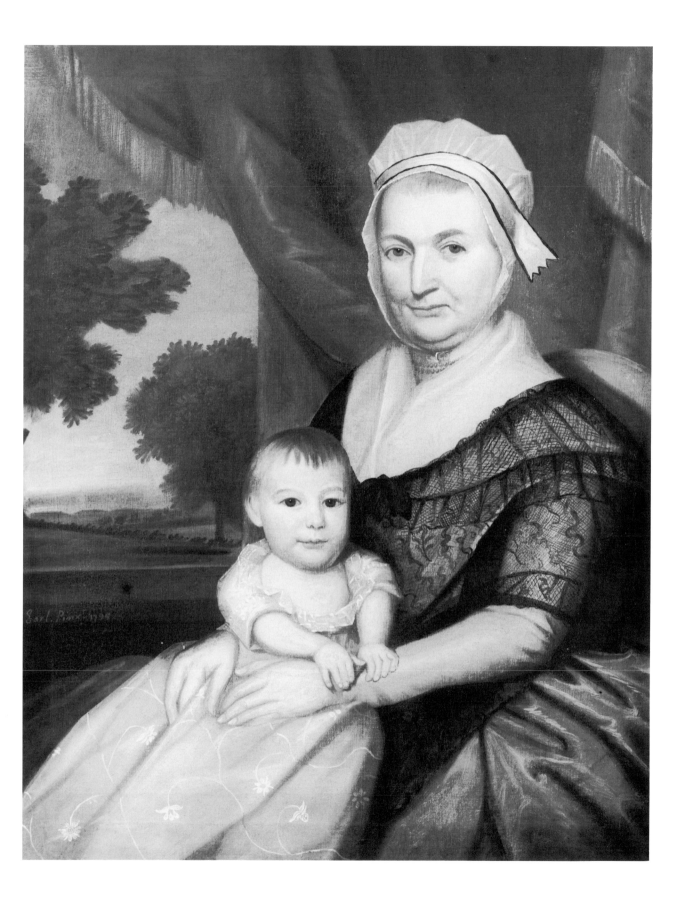

101 RALPH EARL. *Mrs. John Nichols*

Ralph Earl (1751-1801)

41 *Colonel William Taylor*
Oil on canvas, 48½ x 38 in.
Signed at lower left: "R. Earl Pinxt/ 1790."
Original frame carved by the sitter
Albright-Knox Art Gallery, Buffalo, New York

William Taylor (1764-1841), son of the Reverend Nathaniel and Tamar (Board-man) Taylor, was born in New Milford, Connecticut, where Earl painted portraits of more than twenty Boardman family connections. Following service in the Revolution, Taylor graduated from Yale College in 1785 and taught school in New Milford, where he built a house on the green next to his father's church. He owned considerable property in the town and was listed as a "merchant" in the Assessor's List of 1793.

Earl was already proficient in combining landscape with portraiture by the time he returned to America in 1785, and this fine composition illustrates one of the typical window views that add charm to many of his American pictures. Colonel Taylor, garbed in a fashionable gray-brown coat with green and white striped vest, was an amateur artist and is posed sketching the adjacent countryside, emphasizing the popular landscape theme that recurs in so many of Earl's Connecticut pictures.

Refs.: William Sawitzky, *Ralph Earl, 1751-1801* [exhibition catalogue] (New York: Whitney Museum of American Art, 1945), no. 23; *The American Earls* [exhibition catalogue] The William Benton Museum of Art, The University of Connecticut, (Storrs, Conn., 1972), no. 7.

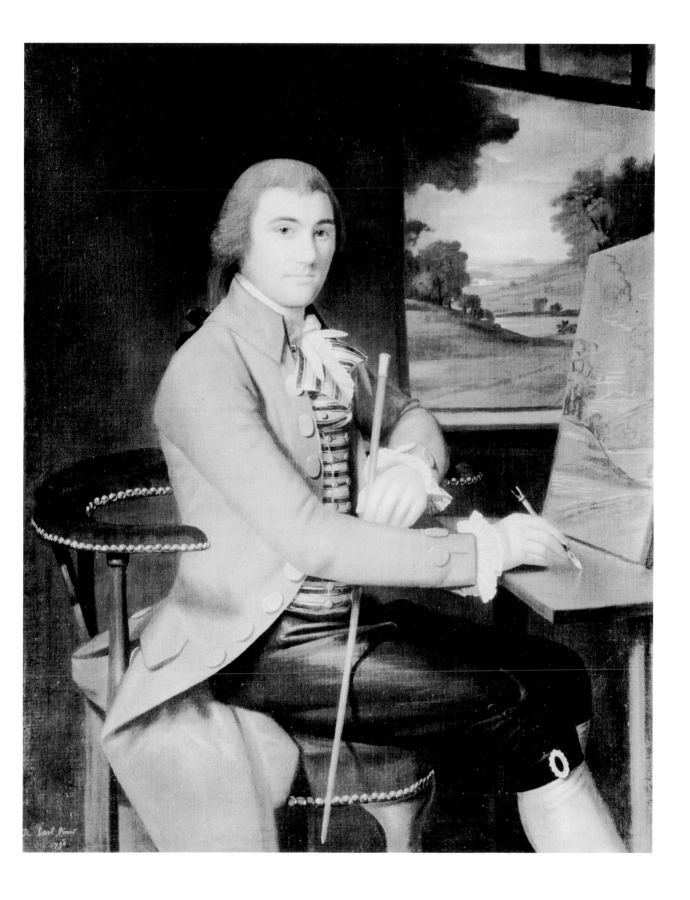

103 RALPH EARL. *Colonel William Taylor*

Ralph Earl (1751-1801)

42 *The Angus Nickelson Family*
Oil on canvas, 42½ x 58 in.
Mr. Nickelson holds an envelope in his right hand inscribed: "Mr. Angus Nickelson/mercht/New York"
Museum of Fine Arts, Springfield, Massachusetts

Angus Nickelson (1735-1804) was born on the island of Isle, Argylshire, Scotland. He came to America in 1762 and in 1765 settled in New Milford, Connecticut, where he married Sarah Platt and became the father of nine children. A prominent community leader, he acquired much property in connection with his mill and iron works in the Merryall section of the town. A handsome silver plaque with the Nickelson family register and coat-of-arms was engraved by Richard Brunton, probably between 1789 and 1791, and is one of only two fully signed examples of Brunton's work (no. 22).

Earl's ambitious interior depicts Mr. and Mrs. Nickelson and seven children seated in a matching set of red-upholstered sofa and chairs in their New Milford home. The shelves of calf-bound books, red and yellow patterned carpet, olive green woodwork, red window draperies and pair of looking glasses all reflect the dignified elegance of a prosperous country home. Although a familiar form in eighteenth century English art, the formal "conversation piece" was relatively rare in America, and Earl no doubt derived inspiration for this painting from his English observations. Another interesting aspect of this unique picture is its original trompe l'oeil enframement, now partly lost and obscured beneath a later gilt frame. It once consisted of a painted gold beaded molding with wide outer member and a dark green liner. Surviving painted frames are rare on eighteenth century pictures. A second example is on Earl's portrait of the Reverend Judah Champion, dated 1789, owned by the Litchfield Historical Society.

Refs.: Museum of Fine Arts, Springfield, Mass., *Bulletin* 35, no. 5 (June and July, 1969), 2, 4; Albert C. Bates, *An Early Connecticut Engraver And His Work* (Hartford, 1906), pp. 12, 28, 32.

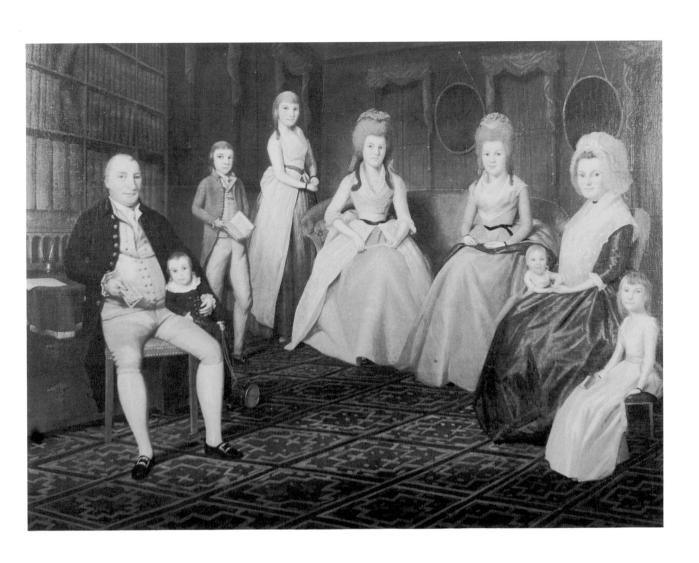

105 RALPH EARL. *The Angus Nickelson Family*

Jonathan W. Edes (b. 1751)

43 *View of Boston Light* (overmantel seascape)
Oil on wood, 25½ x 78 in.
Signed on front in upper right corner: "1789/ Jona. W. Edes pinct."
Original architectural surround
Mr. and Mrs. Bertram K. Little

Boston Light, situated on an island at the entrance to Boston Harbor, is considered the oldest light station in the United States. The first lighthouse on this site was constructed in 1714, at which time the keeper received fifty pounds per annum. On June 13, 1776, during the evacuation of Boston, the British blew up the light, leaving the harbor without a beacon until the tower shown here was erected in 1783. The new structure (which has since undergone various modifications) was seventy-five feet in height with lower walls seven and one-half feet thick, and was topped by an octagonal lantern. Throughout the eighteenth century the light keepers served also as harbor pilots, and one of them may be recognized peering through a spyglass, while another is en route to the incoming vessel.

Jonathan Edes was the son of William and Rebecca (Hawkins) Edes of the well-known Charlestown family. When he was twenty-one years of age, his mother deeded to "Jonathan Welch Edes, Painter," pew 67 in Boston's New North Church. He served as captain in Thomas Craft's regiment of artillery from 1776 to 1779, thereafter removing to Waltham, Massachusetts. In 1789 he was commissioned to paint this overmantel scene in the home of Josiah Sanderson in Waltham, which was demolished in 1894. Edes painted two other overmantels in Waltham, one of them depicting John Boyce's paper mill. He offered to paint the room at no extra charge if he considered the paper sufficiently handsome! By 1798 Edes had returned to Boston, where he was designated as a painter in the street directories until 1803.

In February 1789, *The Massachusetts Magazine* carried an article on Boston Light illustrated with an engraving that showed the left half of Edes' overmantel view. The engraving was signed by S. Hill as delineator and by J. Edes as the artist of the original drawing. It seems probable that Edes used his Boston Light view yet a third time. Late in October 1789, President Washington paid an official visit to Boston. The public procession in his honor comprised numerous divisions of merchants, shopkeepers, and tradesmen each carrying a banner symbolic of its trade or craft. The banner of the Maritime Society depicted "a ship passing the Lighthouse and a boat going out to her," which was probably painted by Edes. This competent artisan-painter has left to posterity a unique pictorial record of an important eighteenth century Boston landmark.

Refs.: Thomas Knox, "Boston Light House . . ." *The Massachusetts Magazine* 1 (Feb. 1789), 66-69; *Waltham Free Press,* Sept. 13, Sept. 27, 1864; *Essex Journal and New Hampshire Packet,* Oct. 28, 1789.

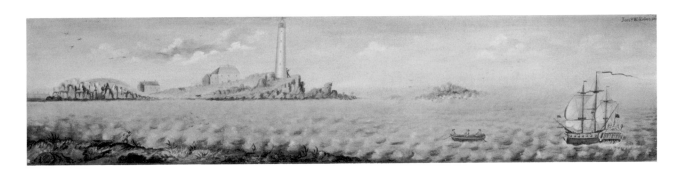

107 JONATHAN W. EDES. *View of Boston Light*

Captain Simon Fitch (1758-1835)

44 *Ephraim Starr*
Oil on canvas, 59 x 39$^{15}/_{16}$ in.
An early nineteenth century stretcher label reads: "Portrait of
Ephraim Starr/ Taken in the 57th Year of His Age/ By Simon Fitch
in Feby 1802"
Wadsworth Atheneum, Hartford, Connecticut

Ephraim Starr (1745-1809) came from Middletown, Connecticut. After going to
sea in his youth, he became a clerk in the store of Uri Hill in Goshen. He married
Mr. Hill's widow in 1769 and took over the business, from which he had made a
considerable fortune by the time of his retirement in 1793. Lying on the table in the
painting is a sheet of paper upon which he has written, "20 shares/ New York/
Bank." This may refer to a large and profitable venture at the close of the Revolu-
tion, when Starr visited New York before the evacuation of the British troops to
purchase unwanted goods at low prices. These he brought back to Goshen and sold
to advantage in his store.

Simon Fitch was born in Norwich, Connecticut, a descendant of the distin-
guished first settler James Fitch. Simon moved to Lebanon with his family when a
child, and in 1783 he married Wealthy Huntington, daughter of a family with
prominent Norwich connections. It is uncertain whether or not Fitch served in the
Revolution, but he was commissioned captain of the Third Company, Fifth Regi-
ment of Cavalry in October 1795.

Contemporary references to Fitch as an artist are rare. Among them is an entry
in the account book of Dr. John Wattrous (owned by the Connecticut Historical
Society) that contains the following notation, dated May 1801:

> To cash paid Capt Fitch for taking [stepson's] portrait $18 5 8 0
> To boarding Fitch & Horse while doing same 12 0

An advertisement typical of the time appeared in the *Connecticut Journal* for
December 14, 1796: "Mr. Fitch Portrait Painter Respectfully informs the citizens
of New-Haven that he expects to spend a few days in town . . . He would be happy
to afford his services to any who feel disposed to oblige him with their custom."
Fitch's authorship of a bust portrait of Noah Clarke of Keene, New Hampshire
(owned by the Fogg Art Museum) is certified by a diary reference, and this picture
together with the two labeled Starr portraits, provide the documentary basis for
appraisal of the artist's style. This has resulted in the reattribution of several
Connecticut portraits of the Huntington family who were related to Fitch through
marriage. Although few facts are available concerning Fitch's painting career,
Ephraim Starr, with his green Windsor chair and eye-catching painted floor, is a
fine example of the robust, true-to-life portraiture that sprang up in New England
soon after the close of the Revolutionary War.

Refs.: William Lamson Warren, "Captain Simon Fitch of Lebanon 1758-1835, Portrait
Painter," *Connecticut Historical Society Bulletin*, 26, no. 4 (Oct. 1961); idem, "The Starr
Portraits by Simon Fitch of Lebanon," *Wadsworth Atheneum Bulletin*, (winter 1961), 7-17.

109 CAPTAIN SIMON FITCH. *Ephraim Starr*

Captain Simon Fitch (1758-1835)

45

Mrs. Ephraim Starr
Oil on canvas, 58⅝ x 40¹⁄₁₆ in.
Stretcher label reads: "Portrait of Hannah Starr/ taken in the 56th
Year of her Age/ by Simon Fitch in Feby 1802"
Wadsworth Atheneum, Hartford, Connecticut

Hannah (Beach) Starr (1745-1826) was born and died in Goshen, Connecticut,
where she became the mother of nine children. Her first husband, Uri Hill, died of
smallpox in 1766, after which his produce and timber business was carried on by
his clerk Ephraim Starr. Three years later Starr married the widow Hill. Mrs. Starr
was fifty-five years of age when she sat for this portrait dressed in her best green
gown. The fashionable gathered waistline, white fichu, embroidered cap, and
accompanying fan bespeak the wife of a prosperous country tradesman. Fitch has
boldly posed his subject within a few feet of the viewer, her voluminous skirt more
than filling the canvas. Her eyes are shrewd and appraising, and her expression is
quite devoid of the masklike refinement that characterized much Colonial
portraiture. Likenesses such as this exemplify the newly emerging democratic spirit
of the young Republic.

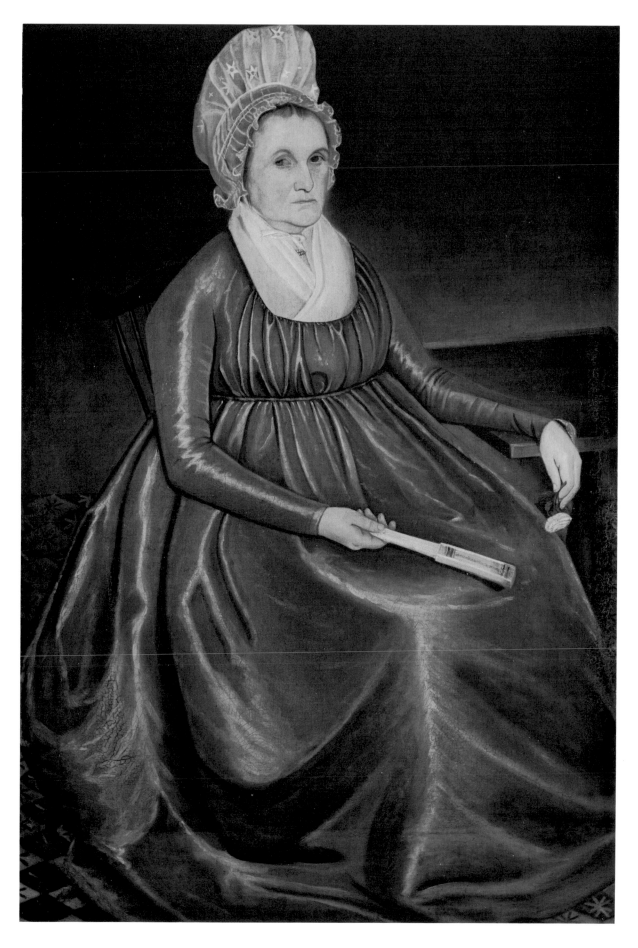

111 CAPTAIN SIMON FITCH. *Mrs. Ephraim Starr*

Christian Gullager (1759-1826)

46 *Mrs. Nicholas Salisbury*
1789, oil on canvas, 35⅞ x 28¾ in.
Worcester Art Museum, Worcester, Massachusetts

Martha (Saunders) Salisbury (1704-1792) was born and lived in Boston until she moved to Worcester in 1775 to make her home with her son Stephen Salisbury I. This portrait, according to the original receipt, was painted by Gullager on July 10, 1789, for the sum of £5.12. It depicts Mrs. Salisbury at eighty-four years of age, attired in an olive silk gown and sitting in a capacious wing chair upholstered in soft rose damask. The snuffbox, steel-rimmed spectacles, and open Bible beneath her hand were considered appropriate accessories for a woman of her advanced years. Depicting her as a tiny but commanding figure with bright beady eyes, Gullager has caught and transmitted the very essence of alert old age.

Like Michele Felice Cornè, Christian Gullager was born in Europe but spent his most productive years painting in New England. Born in Copenhagen and trained there at the Academy of Arts, he arrived in America immediately after the close of the Revolution. His marriage to Mary Selman of Marblehead is recorded on May 9, 1786, in the Newburyport Vital Records. Six portraits painted in Newburyport and one in Gloucester (no. 47) appear to date from this period. By 1789 Gullager was listed in Boston as a portrait painter. On October 27 of that year he made a sketch of President Washington from a pew behind the pulpit of King's Chapel that was to result in the portrait now owned by the Massachusetts Historical Society.

Like many other provincial artists, Gullager plied his trade in fields other than portraiture. His "perspective views" are referred to in 1789 in the journal of Dr. Jeremy Belknap, minister of the Federal Street Church, and two symbolic figure drawings appeared as engraved frontispieces in the second volume of the *Massachusetts Magazine* in 1790. The *Diary of William Dunlap* states that Gullager also painted scenery for the Federal Street Theatre, which opened in Boston on February 3, 1794. In 1797, he was in New York City offering portraits, decorations for buildings, frontispieces for publications, painting on silk for military standards and announcing the establishment of a drawing school. He subsequently moved to Philadelphia, where he advertised miniature painting from 1803 to 1805. There in 1809 his wife divorced him "on account of his inability to support her and his gambling propensities." He died in Philadelphia in 1826. It is, however, his early New England portraits that have earned for Gullager just recognition as a significant artist of ability and character.

Ref.: Louisa Dresser, "Christian Gullager: An Introduction to His Life and Some Representative Examples of His Work," *Art in America* 37, no. 3 (July 1949).

113 CHRISTIAN GULLAGER. *Mrs. Nicholas Salisbury*

Christian Gullager (1759-1826)

47 *The Reverend Eli Forbes*
 Oil on canvas, 45¾ x 40⅛ in.
 Original black and gold frame
 Mr. and Mrs. Bertram K. Little

Eli Forbes (1726-1804) was born in Westborough, Massachusetts, graduated from Harvard College in 1751, and was minister of the Second Parish in Brookfield, Massachusetts, from 1752 to 1775. In 1776 he was settled over the First Church in Gloucester and remained there until his death in 1804. He married four times. The Reverend Forbes is shown in a familiar pose, exhorting his congregation from the pulpit of the old Gloucester meeting house, which stood on the green adjacent to the modern bridge that now spans the Annisquam River. The leaves of a sermon lie on the Bible before him, and a green-curtained window adds interest to the dark background.

Because of strong similarity in the style and execution of this picture to the robust portraits of the Boardman and Coates families taken in Newburyport in 1787, it is presumed that Gullager painted the Reverend Forbes in Gloucester before removing to Boston, where he was established as a portrait painter by 1789.

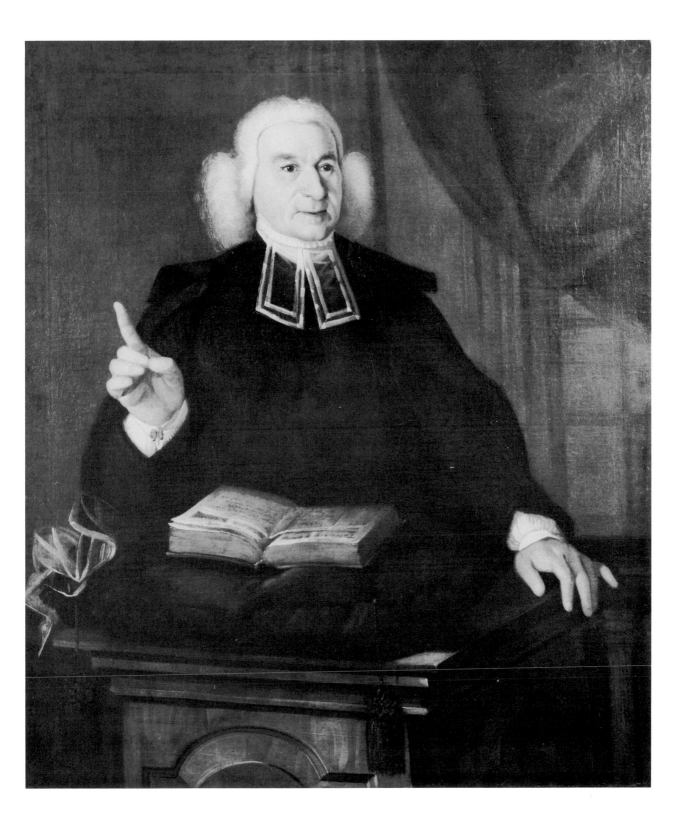

115 CHRISTIAN GULLAGER. *The Reverend Eli Forbes*

Dr. Rufus Hathaway (1770-1822)

48 *The Reverend Caleb Turner*
Oil on canvas, 34½ x 33 in.
Signed on front in lower right corner: "In anno 1791/ Aetatis Suae
58/ Rufus Hathaway P[inx]."
Original marbleized frame
Old Colony Historical Society, Taunton, Massachusetts

Caleb Turner (1733-1803) was born in Mansfield, Connecticut, and graduated
from Yale College with the class of 1758. After completing his theological studies,
he was settled in 1760 over the church in Middleborough and Taunton Precinct
(now Lakeville), Massachusetts, where he remained for forty-one years. His yearly
salary at time of settlement was 40 pounds, 13 shillings, and 4 pence, but due to
inflation of currency, the church was so far behind in its payments that he offered
to take the equivalent of 40 pounds in farm produce, bar iron, or iron hollowware.
He owned considerable property, including one-quarter of a gristmill, and left a
comfortable estate that included a large and varied ecclesiastical library. The artist
has captured here the fanatical intensity of an eighteenth century parson, with
flowing wig and Bible under arm.

Rufus Hathaway, believed to have been born in Freetown, Massachusetts, was a
descendant in the seventh generation from Nicholas Hathaway, one of the original
purchasers of Taunton about 1640. Said by family tradition to have ridden into
Duxbury on horseback in the early 1790's as an itinerant painter, he settled there
and married Judith Winsor in December of 1795. Her father, one of the most
prominent merchants in the town, persuaded his son-in-law to enter the more
highly respected profession of medicine, and following study with Dr. Isaac
Winslow in nearby Marshfield, Hathaway practiced for twenty-seven years as the
only physician in Duxbury. In 1822, as a mark of professional recognition, he was
elected an honorary fellow of the Massachusetts Medical Society.

Despite lack of encouragement from his conservative in-laws, Hathaway painted
a series of remarkable portraits of about twenty Duxbury people during the 1790's.
One group comprised seven pictures of his wife's Winsor relatives, while another
included ten portraits depicting three generations of the wealthy Ezra Weston
family. Three interesting miniatures by Hathaway are also recorded, one a self-
portrait. He likewise executed decorative carvings. One of these was a large spread
eagle made to ornament a triumphal arch raised above a controversial new bridge
that was built to span the Bluefish River in 1803. Hathaway appears to have had
little or no artistic training. He possessed, however, an extraordinary sense of linear
design, which endows all of his work with a monumental quality that transcends
his obvious limitations in anatomy and technique.

Ref.: Nina Fletcher Little, "Doctor Rufus Hathaway," *Art in America* 41, no. 3 (summer
1953).

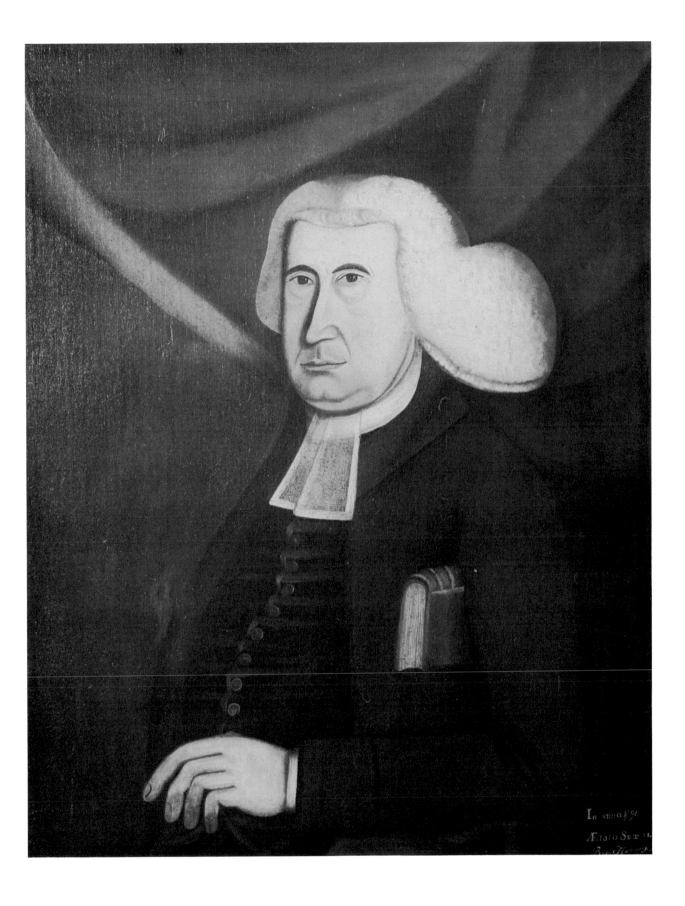

117 DR. RUFUS HATHAWAY. *Reverend Caleb Turner*

Dr. Rufus Hathaway (1770-1822)

49 *Mrs. Caleb Turner*
1791, oil on canvas, 34½ x 33 in.
Original marbleized frame
Old Colony Historical Society, Taunton, Massachusetts

Phebe (King) Turner (1740-1818) was the daughter of Jonathan and Phebe (Leonard) King of Raynham, Massachusetts. She married the Reverend Caleb Turner at an undetermined date. Having no children of their own, the Turners raised a young man as their son for whom Mrs. Turner provided $200.00 in her will. Showing the sitter in a brown silk gown with flower-ornamented fan, the portrait is a compelling study that evokes the stark quality of a tombstone carving.

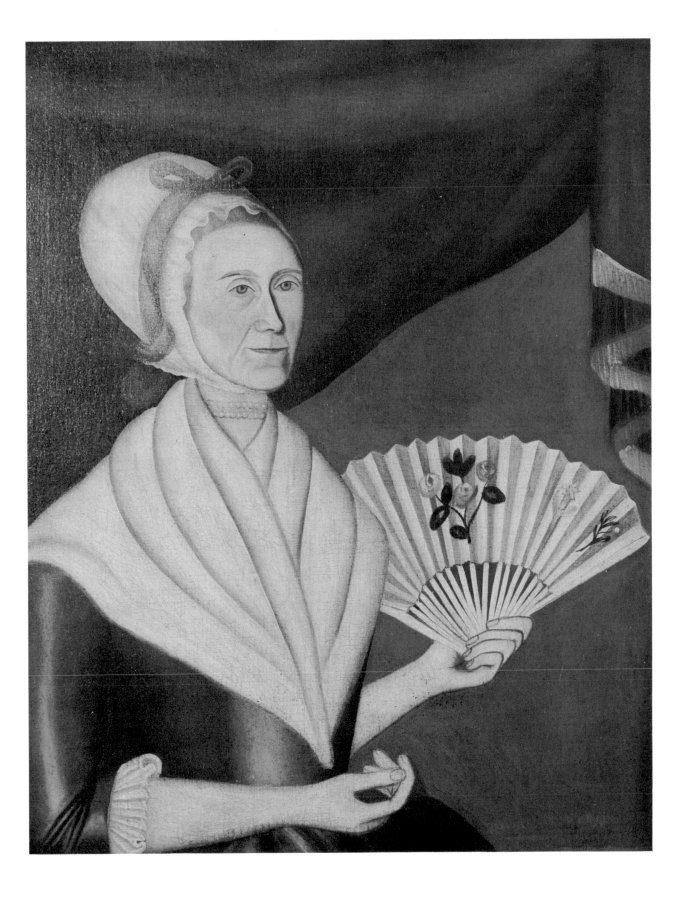

119 Dr. Rufus Hathaway. *Mrs. Caleb Turner*

Dr. Rufus Hathaway (1770-1822)

50

Ezra Weston, Jr.
Oil on canvas, 37¾ x 25 in.
Inscribed on reverse: "Ezra Weston/ Son of/ Ezra & Salumith/ Born Novr 30th 1772 / Died Augt 15th 1842/ Mard/ June 2 1793/ Jerusha Bradford."
Original black and gold-leaf frame
Abby Aldrich Rockefeller Folk Art Collection, Williamsburg, Virginia

Ezra Weston, Jr. (1771-1842), was the son of Duxbury's so-called King Caesar, one of the wealthiest and most enterprising shipowners and builders on the New England coast. Ezra, Jr., went into partnership with his father in 1798 and carried on the firm after the latter's death in 1822. In 1837 Lloyds of London listed more than one hundred ships under his ownership and referred to him as the "largest ship owner in America." It is said that Weston-owned vessels flying the family's red, white, and blue striped house flag were to be seen trading in all parts of the world. Cordage was made in Ezra's own ropewalk, sails in his loft, anchors in his forge, and his commercial transactions were carried on at the Duxbury bank of which he was president. This is one of Hathaway's finest and most impressive compositions, as befitted the importance of the Weston family.

On January 5, 1793, Hathaway rendered a bill to Ezra Weston, Sr., for "painting 6 portraits at £1-10" each. The individual frames cost 3 shillings, with a like sum charged for their painting and gilding. The artist receipted the account on June 24. It seems probable that this picture and frame were included in the group of six.

121 DR. RUFUS HATHAWAY. *Ezra Weston, Jr.*

Dr. Rufus Hathaway (1770-1822)

51 *Joshua Winsor's House,* Duxbury, Massachusetts
Oil on canvas, 23¼ x 27½ in.
Original black-painted frame
Lettered below picture: "A View of Mr. Joshua Winsor's House &c."
New England Historic Genealogical Society, Boston

Joshua Winsor was the father-in-law of Rufus Hathaway, who married his daughter Judith in 1795. Winsor was extensively engaged in the mackerel and cod fishing industry on the Grand Banks. Winsor's substantial red-painted house, built ca. 1768 and destroyed by fire in 1886, stood on Powder Point in Duxbury. The painting shows his wharves, counting house, and large fleet of vessels lying at anchor, while the owner himself, bunch of keys in hand, appears in the right foreground. A man standing on a nearby boat is shown in the act of shooting two ducks flying overhead with a double-barreled shotgun, an example of sly humor injected by the artist. This is the only landscape so far attributed to Hathaway.

Several interesting items connected with the medical profession were listed in Hathaway's inventory of 1822. These included his medical library worth $40.00, medicine and bookcase $5.00, two pocket cases containing surgical instruments, and "a thermometer and tooth drawers at $1.00 each." Unfortunately, there is no reference to painting equipment, with the possible exception of one intriguing entry that lists "carved work and picture hangings" [frame moldings?] at $4.50.

See also colorplate, p. 14.

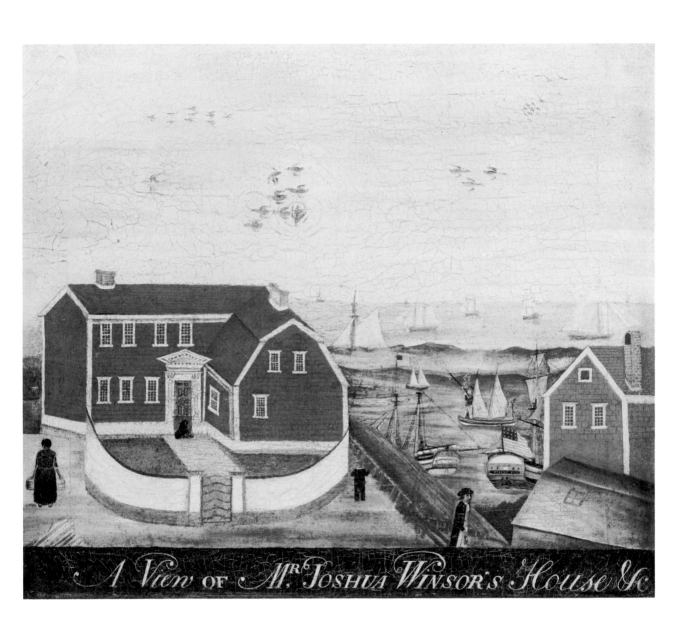

123 DR. RUFUS HATHAWAY. *Joshua Winsor's House*

Richard Jennys (active 1766-1798)

52 *Isaac Hawley, Jr.*
Oil on canvas, 29¾ x 24½ in.
Signed on reverse under relining: "Isaac Hawley's portrait, aged 42/
Richd Jennys pinxt Novemr 5, 1798"
The Connecticut Historical Society, Hartford

Isaac Hawley, Jr. (1756-1839), was one of several leading citizens whom Richard Jennys painted in New Milford, Connecticut. Owner of property numbering more than one thousand acres, he was active in various business enterprises and built at his own expense Hawley's Bridge, the first bridge to span the Housatonic River.

Birth and death dates for Richard Jennys are unknown, and despite diligent search by William Warren and others, no information about his career has come to light except that derived from his paintings and from the newspaper advertisements that appeared in several cities where he worked. His earliest known portrait is a signed mezzotint of the Reverend Jonathan Mayhew, pastor of Boston's West Church. This was offered for sale by Nathaniel Hurd in 1766 and is now in the collections of the American Antiquarian Society. The Reverend Mayhew is posed within an oval in the manner of eighteenth century engravings, and in later years the artist continued to employ this device to good effect. Jennys evidently traveled to Charleston, South Carolina, in 1783, where, in a notice in the *South Carolina Weekly Gazette,* his arrival from Boston in the ship *Peggy and Polly* was reported on October 31. In November he advertised "Portrait Painting in all its branches" and mentioned previous residence in the West Indies. The years 1785 to 1791 found him in Savannah, Georgia, where "portrait painting in miniature" became an additional part of his repertoire. In 1792 he returned to New Haven and advertised "chaise and other Painting" and also the opening of a school to instruct "in the Art of Drawing and Painting Flowers, Birds, Landscapes or Portraits." Jennys was obviously experiencing the necessity, known to many artists, of finding new sources of income when portrait painting alone was not sufficient to provide even a meager living. From 1794 to 1798 Jennys worked in New Milford, and there he achieved the success that had apparently eluded him in his earlier travels. It was in this area that the small group of pictures now attributed to him were painted. These include the signed Hawley pictures and one of Reuben Booth, all of which serve as keys to the characteristics of his work. His sitters are posed stiffly, often in ovals, without benefit of flowers, books, or fans. But Richard Jennys' competent, fresh-faced likenesses make a special contribution to the body of New England provincial art.

Refs.: William Lamson Warren, "The Jennys Portraits," *Connecticut Historical Society Bulletin* 20, no. 4 (Oct. 1955); idem, "A Checklist of Jennys Portraits," *Connecticut Historical Society Bulletin* 21, no. 2 (April 1956).

125 RICHARD JENNYS. *Isaac Hawley, Jr.*

Richard Jennys (active 1766-1798)

53 *Mrs. Isaac Hawley, Jr.*
Oil on canvas, 29½ x 24¼ in.
Signed on reverse below relining: "Tamer Hawley, Aged 31,/
R. J. Pinxt. 1798"
The Connecticut Historical Society, Hartford

There exists little information about Tamar Hawley (1767-1805) beyond the fact that her portrait is one of three presently known examples signed by Richard Jennys. She was born in Newberry Parish, Connecticut, established in 1754 from portions of Danbury, New Milford, and Newtown. She became the mother of four children and died in Brookfield at the age of thirty-eight years. Tamer's plum satin gown, beribboned cap, and double strand of gold beads were no doubt her best attire, donned for the special occasion of having her portrait painted.

127　Richard Jennys. *Mrs. Isaac Hawley, Jr.*

William Jennys (active 1795-1806)

54
Mrs. Reuben Hatch
Oil on canvas, 30 x 25 in.
Signed on reverse: "Eunice Hatch AE 38/ W. Jennys pinxt April 21st 1802"
Lyman Allyn Museum, New London, Connecticut

Eunice (Denison) Hatch (1764-1842) was the daughter of Daniel and Esther (Wheeler) Denison of Stonington, Connecticut. She married Reuben Hatch in Stonington on May 9, 1794, and moved with him to Norwich, Vermont (then New Hampshire), where he was a successful farmer, and where Jennys painted their portraits in 1802.

No biographical material has come to light concerning William Jennys. There has been speculation that he emigrated from England in company with Richard Jennys, and it seems probable that the two men were in some way related. Many more portraits are attributed to William than to Richard, but both painted in the New Milford, Connecticut, area in the 1790's, at which time their work was quite similar in style. William eventually traveled northward through central Massachusetts and Vermont and across New Hampshire to the coastal town of Newburyport. During the opening years of the nineteenth century he adopted a distinctive technique quite different from that of any of his contemporaries. Unlike such artists as Winthrop Chandler and Rufus Hathaway, the effectiveness of whose compositions depended in large part on flat, unshaded linear design, Jennys' faces were strongly modeled with rose flesh tints contrasting with gray. In the lively image of Mrs. Hatch, which is typical of his best female portraits, he made good use of well-defined sources of light that cast prominent shadows across the features. By this means he achieved a likeness that is unique and unforgettable. Almost a dozen of Jennys' pictures are signed, and therefore the recognition and appraisal of his work has been considerably aided.

Refs.: William Lamson Warren, "The Jennys Portraits," *Connecticut Historical Society Bulletin* 20, no. 4 (Oct. 1955); idem, "A Checklist of Jennys Portraits," *Connecticut Historical Society Bulletin* 21, no. 2 (April, 1956).

129 WILLIAM JENNYS. *Mrs. Reuben Hatch*

William Jennys (active 1795-1806)

55 *Cephas Smith, Jr.*
Oil on canvas, $41\frac{1}{4}$ x $31\frac{1}{2}$ in.
Museum of Fine Arts, Boston, Massachusetts

Cephas Smith, Jr. (1760-1815) was born in Suffield, Connecticut, and later moved
to Rutland, Vermont, where he became a well-known lawyer. The painting shows
him writing a letter, which bears at the top "Rutland" and what appears to be the
curious date "1916." A satisfactory explanation of this has yet to be found. The
figure "9" may have been an error for the figure "8." As Cephas Smith died in 1815,
and the baby in the portrait of his wife (no. 56) was born in 1805, the correct date
of the pictures was probably ca. 1806.

In the Smith portraits Jennys has reverted to the three-quarter-length style of the
eighteenth century rather than using the waist-length pose that he habitually pre-
ferred. Ovals surrounding the figures have been omitted in favor of fully developed
backgrounds that include upholstered chairs and colorful drapery. The canvas size,
also, which is considerably larger than that normally used by Jennys, makes the
pictures particularly impressive examples of this artist's work.

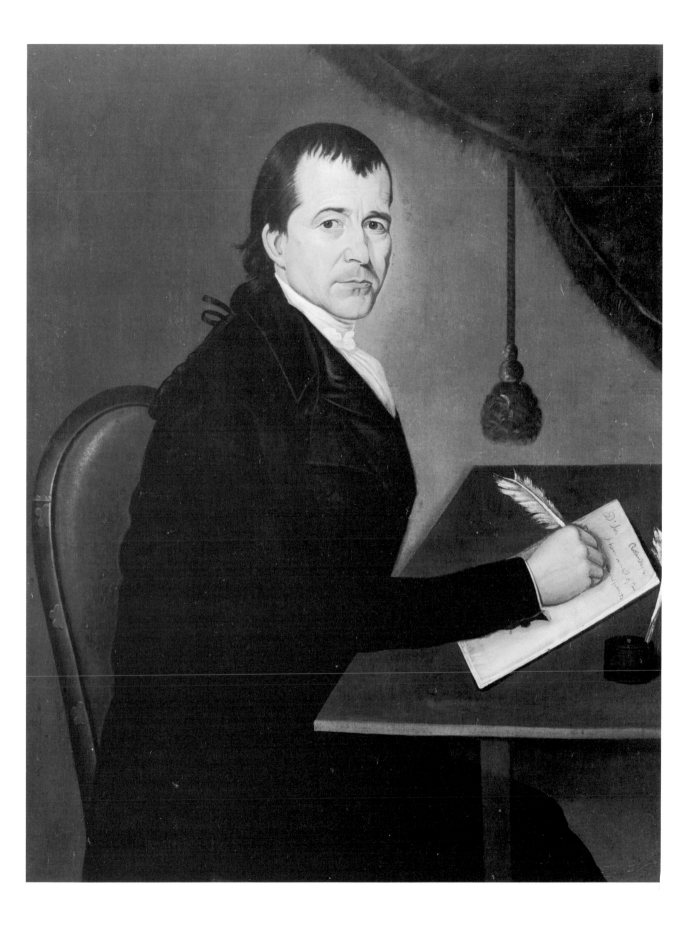

131 WILLIAM JENNYS. *Cephas Smith, Jr.*

William Jennys (active 1795-1806)

56 *Mrs. Cephas Smith, Jr.*
 Oil on canvas, 41¼ x 31½ in.
 Museum of Fine Arts, Boston, Massachusetts

Mary (Gove) Smith (b. 1775) is thought to have married Cephas Smith about 1795. The baby shown in the portrait, one of their five children, was Mary Page Smith, who was born in June 1805 and died in 1831.

Compositions including mother and child were favorites in the post-Revolutionary period, and several others are included in the exhibition. Few provincial artists, however, succeeded in depicting small children as successfully as they portrayed their parents.

See also colorplate, p. 16.

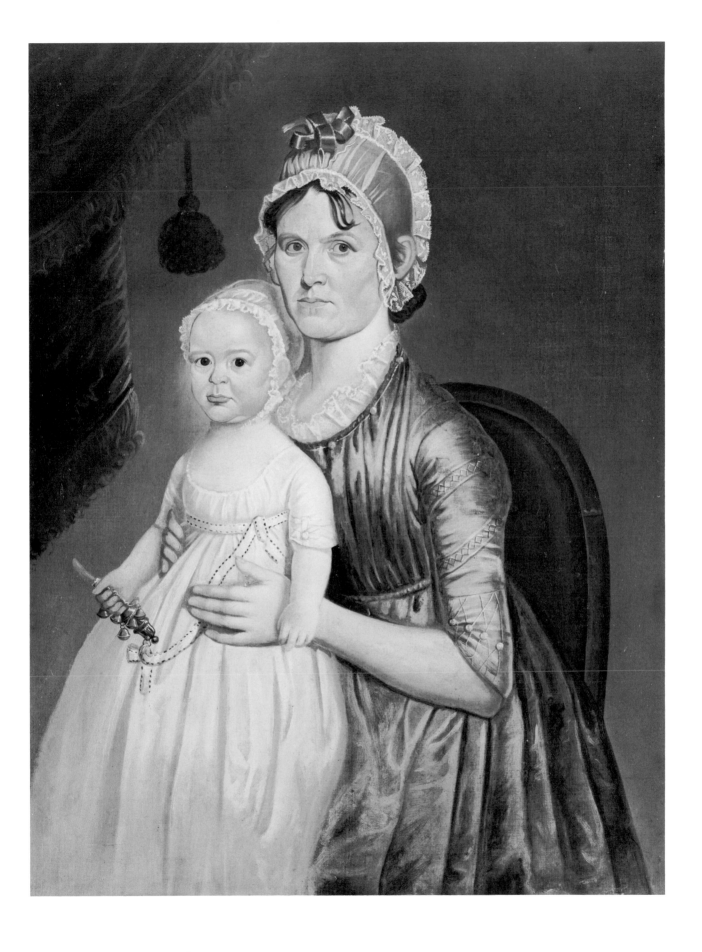

133 WILLIAM JENNYS. *Mrs. Cephas Smith, Jr.*

William Jennys (active 1795-1806)

57
 Colonel Constant Storrs
Oil on canvas, 29¾ x 25 in.
Signed on reverse: "Col. Constant Storrs AE. 50 / Wm Jennys Pinxt
June 23 1802"
Pennsylvania Academy of the Fine Arts, Philadelphia

A native of Mansfield, Connecticut, Constant Storrs (1752-1828) removed in 1780 to Lebanon, New Hampshire, where he spent the rest of his life. His portrait was painted there two months after that of Mrs. Reuben Hatch (no. 54), which was executed in the neighboring town of Norwich, now in Vermont.

 Jennys apparently received rather more remuneration for some of his portraits than certain of his contemporaries. An existing account book records that he was paid $24.00 for a pair of portraits of Dr. and Mrs. William Stoddard Williams of Deerfield, Massachusetts, painted in 1801. He also supplied the Williams frames for an additional charge of $2.00.

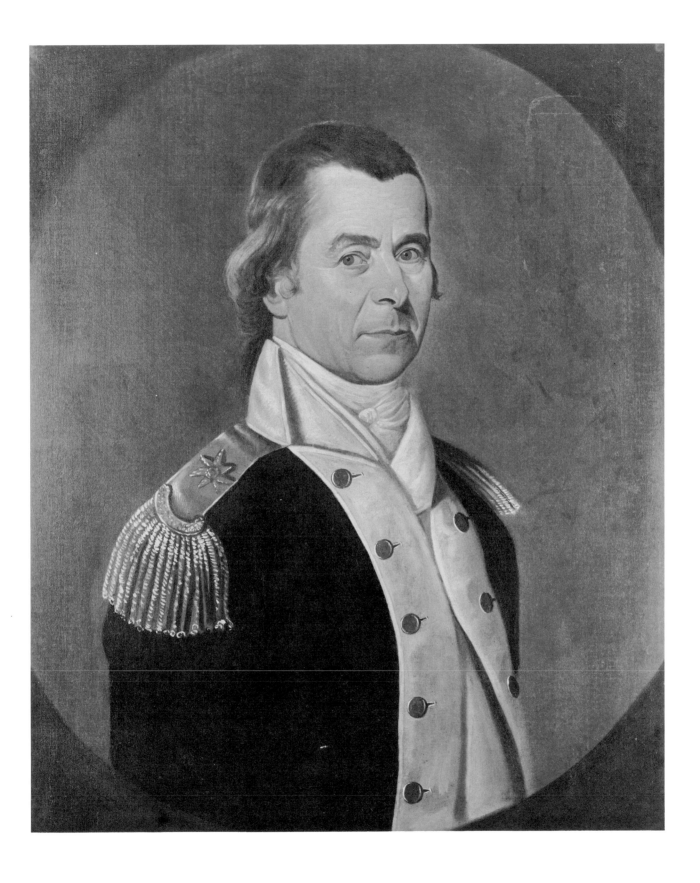

135 WILLIAM JENNYS. *Colonel Constant Storrs*

William Jennys (active 1795-1806)

58 *Mrs. Constant Storrs*
 1802, oil on canvas, 30 x 24½ in.
 Pennsylvania Academy of the Fine Arts, Philadelphia

 Lucinda (Howe) Storrs (1758-1839) was the daughter of Dr. Samuel and Eunice
 (Conant) Howe. She married Constant Storrs on October 3, 1776, and lived in
 Lebanon, New Hampshire. In this sensitive study of Mrs. Storrs, who was only
 forty-four years old at the time, Jennys has conveyed the impression of weariness
 and strain that pervaded the lives of many New England housewives.

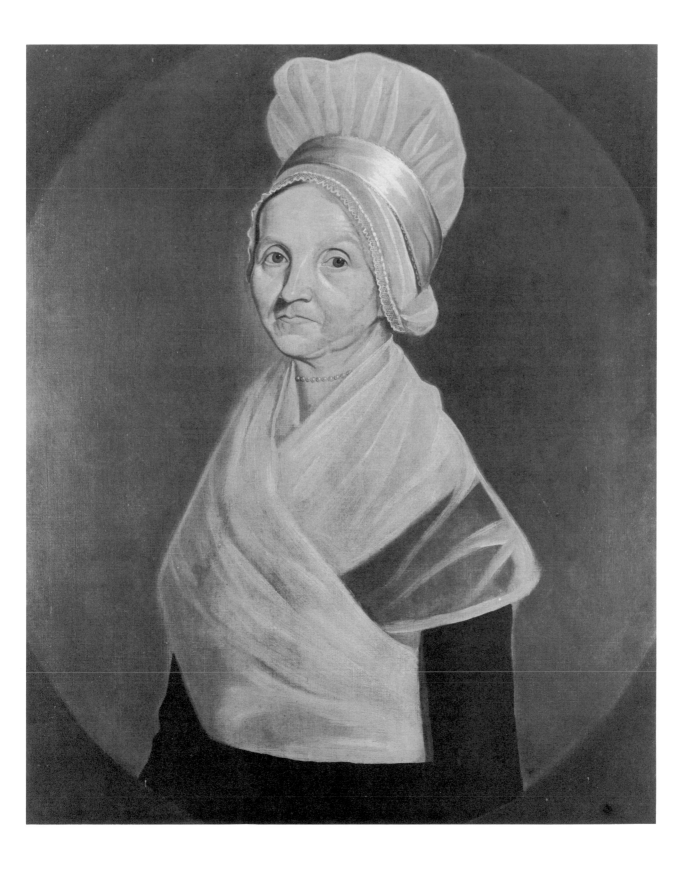

137 WILLIAM JENNYS. *Mrs. Constant Storrs*

John Johnston (active 1752-1818)

59 *Samuel Dexter*
 1792, oil on canvas, 30 x 24 in.
 Original gold beaded frame
 American Antiquarian Society, Worcester, Massachusetts

Samuel Dexter (1725/26-1810) was born in Dedham, Massachusetts, son of the Reverend Samuel and Catharina (Mears) Dexter. He was a merchant, benefactor of Harvard College, and representative from Dedham in the General Court during many years between 1764 and 1785. He was also town clerk, selectman, and member of the Provincial Congress of Massachusetts in 1774-75. According to his will, drawn up in 1799, this portrait, painted when Dexter was sixty-six, was bequeathed to his grandson, Samuel Dexter Ward.

John Johnston was the son of Thomas Johnston of Boston, a well-known engraver, japanner, and heraldic painter during the second and third quarters of the eighteenth century. Two of the sons, John and William, became portrait painters, and two others were jappanners, all trained in their father's Boston shop. John was apprenticed in 1767 to John Gore, house and sign painter and father of Governor Christopher Gore. In 1775 he entered the army and the following year was seriously wounded and taken prisoner during the Battle of Long Island. He resumed work in Boston in 1777 as the partner of his brother-in-law Daniel Rea, Jr., and the firm of Rea and Johnston became ornamental painters to the elite during the post-Revolutionary period. They decorated clock faces, gilded weathercocks and looking glasses, ornamented furniture, and painted floor cloths and signs. Johnston, however, was also painting portraits as early as 1781 and by the late 1780's had taken up portraiture as his established profession. This richly detailed picture of Samuel Dexter in white wig and brocaded dressing gown emphasizes the validity of apprenticeship in the craft tradition, in which so many successful provincial artists were trained.

Refs.: Frederick L. Weis, *"Checklist of the Portraits in the Library of the American Antiquarian Society,"* (Worcester, April, 1947), 25; Sinclair Hitchins, "Thomas Johnston," in *Boston Prints and Printmakers, 1670-1775,* Publications of the Colonial Society of Massachusetts, vol. 46 (Boston, 1973), pp. 83-131; Mabel M. Swan, "The Johnstons and the Reas, Japanners," *Antiques* 43, no. 5 (May, 1943), 211-213.

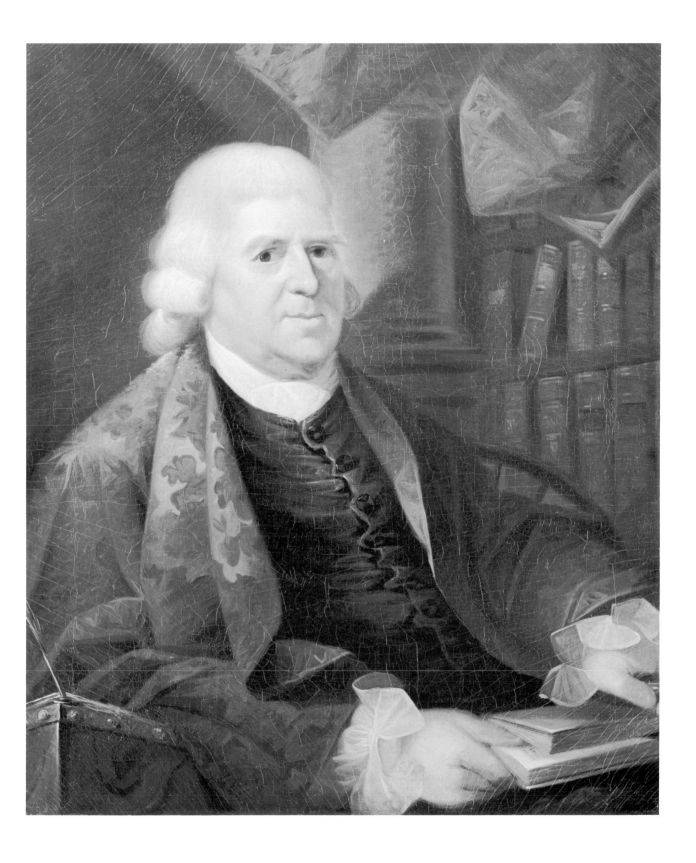

139　John Johnston. *Samuel Dexter*

John Johnston (active 1752-1818)

60 *The Good Samaritan* (signboard)
1797, oil on wood, 41¾ x 46¾ in.
New England Medical Center Hospital, Boston, Massachusetts

The Boston Dispensary, now united with Tufts-New England Medical Center, was organized in 1796 to dispense medicine to the needy poor under the guidance of a consulting physician. Dr. Thomas Bartlett's apothecary shop at 61 Cornhill, Boston, was chosen to be the center of the Dispensary's activities, and in March 1797, Dr. Bartlett was asked to procure a suitable signboard to be placed on the front of his premises. The Dispensary's treasurer's book records Thomas Clements' carpentry bill dated June 1797 as follows: "To making a sign the molding worked out of solid, irons and screws, putting up ditto at your shop for the Dispensatory $7.00." An accompanying receipt of John Johnston reads: "Boston, May 10, 1797—Received of Dr. Thomas Bartlett the sum of thirty dollars, in full for painting a sign of the Good Samaritan." The source of this design was evidently an English engraving, published in 1772, based on a large mural painting by William Hogarth that he had presented to St. Bartholomew's Hospital, London, in 1736. When the signboard needed repair in 1806, Johnston was again retained to do the necessary retouching at a cost of $20.00. It was resurfaced a second time in 1859 by Lorenzo Somerby, a Boston ornamental painter.

In 1815 Dr. Bartlett resigned as "Apothecary to the Institution." He was allowed, however, to retain the sign until 1823, when it was purchased by the Dispensary from Dr. Clarke, Dr. Bartlett's successor. It continued to hang outside Dr. Clarke's premises at 138 Washington Street, until 1845, during which time he served the clinic. Since then the signboard has remained in the Dispensary's possession, a symbol of one hundred and eighty years of unbroken charitable service.

Although he is now esteemed as a portraitist, John Johnston was apprenticed in 1767, when fifteen years old, to the ornamental painter John Gore, and it was no doubt Johnston's ability as a sign painter that gained him the commission of painting *The Good Samaritan*. He is known to have painted at least one other biblical theme, the Descent of the Holy Spirit, for the chancel of Christ Church (Old North), Boston. *The Good Samaritan*, however, is a rare survival of an eighteenth century signboard by an identified Boston artist.

Ref.: Nina Fletcher Little, "The Good Samaritan, Symbol of the Boston Dispensary," *Antiques* 70, no. 4 (Oct. 1956), 360-362.

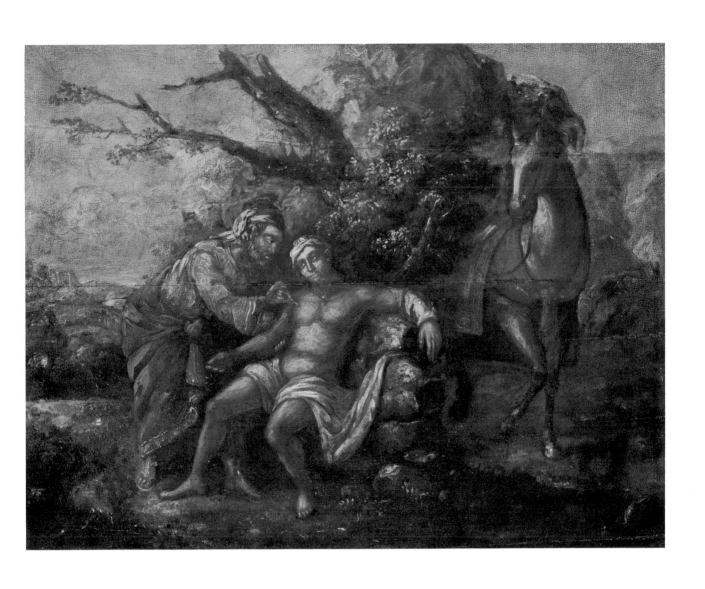

141 JOHN JOHNSTON. *The Good Samaritan*

William Johnston (1732-1772)

61 *Mrs. Thomas Seymour*
 1764, oil on canvas, 50¼ x 40½ in.
 Original black and gold frame
 The Connecticut Historical Society, Hartford

Mary (Ledyard) Seymour (1735-1807), daughter of John and Deborah (Youngs) Ledyard, was baptised in Groton, Connecticut. She married Colonel Thomas Seymour, first mayor of Hartford, and became the mother of seven children. A bill referring to this portrait, owned by the Connecticut Historical Society, reads as follows:

> D.ʳ Mr. Thomas Seymore to William Johnston
> To painting your & Lady picture - - - £ 18.
> To 2 frames @ 45/. 1 Coat of Arms @ 30/. - - - 6.
> £ 24.

Hartford 21st April 1764

William Johnston was the son of Thomas Johnston of Boston and his first wife Rachel Thwing and was an elder half-brother of the artist John Johnston. Both men were raised amidst their father's circle of craftsmen—engravers, gilders, japanners, stone carvers, and heraldry painters—whose varied talents contributed significantly to the richness of Boston's pre-Revolutionary decorative arts. William inherited his father's predilection for music and served as organist of Christ Church (Old North) from 1750 to 1753. His early professional connections were not solely confined to the artisan group. He also came under the influence of his contemporaries John Greenwood, Joseph Blackburn, and John Singleton Copley, and it was doubtless due to these associations that he chose portraiture as his ultimate career. During the early 1760's Johnston undertook two trips to Portsmouth, New Hampshire, presumably to solicit painting commissions. He also worked in New London, New Haven, and Hartford in 1763 and 1764, and while in Connecticut executed a number of handsome three-quarter-length portraits. A letter to his friend Copley reveals that he had moved before 1770 to Barbados, where he continued to paint and to augment his income as an organist at seventy-five pounds per annum. He died suddenly at Bridgetown, Barbados, in August 1772.

Mrs. Seymour's studied pose, her stylishly draped gown, and the conventional landscape vignette betray Johnston's debt to the English portraiture of his day. Despite his limited understanding of anatomy, his ability to project the character of his subjects confirms his position as one of New England's leading provincial artists.

Refs.: Lila Parrish Lyman, "William Johnston (1732-1772)," *The New-York Historical Society Quarterly* 39, no. 1 (Jan. 1955), 63-78; Susan Sawitzky, "The Portraits of William Johnston: A Preliminary Checklist," *The New-York Historical Society Quarterly* 39, no. 1 (Jan. 1955), 79-89.

143 WILLIAM JOHNSTON. *Mrs. Thomas Seymour*

William Johnston (1732-1772)

62

Eliphalet Dyer
Oil on canvas, 49¾ x 41 in.
Original black and gold frame
The Connecticut Historical Society, Hartford

Eliphalet Dyer (1721-1807) was born in Windham, Connecticut, graduated from
Yale College in 1740, and was admitted to the Connecticut Bar in 1746. After
serving as one of the town's deputies in the General Assembly between 1747 and
1753, he became an original member of the Susquehanna Company, which was
working to secure land for its members in northern Pennsylvania. By 1763 Dyer
had become one of the most promising political figures in the colony of Con-
necticut, and as agent for the Susquehanna Company, he sailed for England. There
his stay unfortunately coincided with the development of a new British government
policy. This was to result in the notorious Stamp Act, concerning the implications
of which Dyer appears to have been one of the first to sound the alarm in Con-
necticut. He was an astute politician, and despite being caught in the complex
political crisis following his return to America in 1764, he was exonerated when
confirmation arrived of the official repeal of the Stamp Act in 1766.

This portrait is believed to have been painted by William Johnston in 1764,
shortly after Dyer's return from England. It depicts the handsomely dressed subject
in dignified pose and conventional surroundings. The volume on which he rests his
left hand is titled, *Coke on Littl[eton]*, published in 1628 by the famous English
jurist Sir Edward Coke.

Refs.: "William Johnston Portrait Painter, 1732-1772," *Connecticut Historical Society
Bulletin* 19, no. 4 (Oct. 1954), 97-100. Richard T. Warfle, "Eliphalet Dyer's Stamp Act
Crisis," *Connecticut Historical Society Bulletin* 39, no. 1 (Jan. 1974), 10-13.

145 WILLIAM JOHNSTON. *Eliphalet Dyer*

Samuel King (1748/49-1819)

63 *Mrs. Ezra Stiles*
Oil on canvas, 33 ½ x 27 ½ in.
Signed very faintly at right: "Saml King Pinx 1771 / Eliz. Stiles. AE 41 / 1771"
Yale University Art Gallery, New Haven, Connecticut
Bequest of Dr. Charles C. Foote

Elizabeth (Hubbard) Stiles (1731-1775) was the wife of the Reverend Ezra Stiles, president of Yale College from 1778 until his death in 1795. Her life is perhaps best summarized in her husband's Literary Diary for May 29, 1775, when he wrote: "Early this morning... My Dear Wife Elizabeth Stiles departed this life aetat. 44. It is a day of great grief and Distress... She ordered her Affairs with Wisdom. She took the whole Care of the Family off me upon herself, and did every Thing well."

Samuel King, son of Benjamin, an importer and maker of nautical instruments, was born and lived in Newport, Rhode Island. After Benjamin's death in 1786, Samuel advertised in the *Newport Mercury* that he was continuing his father's business. He also ornamented carriages, painted houses and signboards, engraved scenic views, and accepted portrait commissions when opportunity offered. In 1770 he contracted a prosperous marriage with Amy Vernon, daughter of the influential merchant and silversmith Samuel Vernon. The Reverend Ezra Stiles, minister of the Second Congregational Church and librarian of the Redwood Library, officiated at the ceremony. King began an ambitious portrait of Stiles in 1770 (now in the collection of the Yale University Art Gallery), to be completed with this picture of his wife a year later. Stiles noted in his diary for August 19, 1771: "This afternoon my Wife sat to Mr. King for her picture." Sittings were repeated twice during the following October.

Although a number of portraits have been attributed to Samuel King, signed or documented examples are quite rare, so that the complete range of his work still remains relatively obscure. This likeness of Mrs. Stiles is one of the artist's earliest signed works. Although it exhibits deficiencies in drawing, it renders unmistakably the features of a real person.

Refs.: Howard M. Chapin, "Davis Quadrants," *Antiques* 12, no. 5 (Nov. 1927), 397-399; Josephine Setze, "Portraits of Ezra Stiles," *Bulletin of the Associates in Fine Arts at Yale University* 23, no. 3 (Sept. 1957), 7, 8; William B. Stevens, "Samuel King of Newport," *Antiques* 96, no. 5 (Nov. 1969), 729-733.

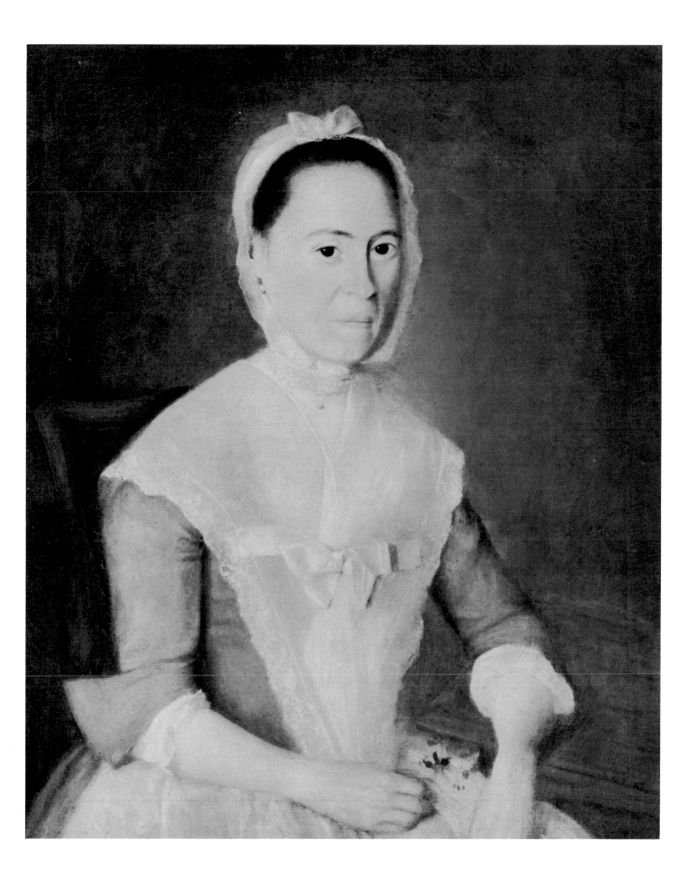

147 SAMUEL KING. *Mrs. Ezra Stiles*

Samuel King (1748/49-1819)

64 *Doctor Isaac Senter*
Oil on canvas, 43½ x 30⅞ in.
Original black and gold frame
The Rhode Island Historical Society, Providence

Isaac Senter (1753-1799) was born in Londonderry, New Hampshire. After study-
ing medicine in Newport, Rhode Island, under Dr. Thomas Moffatt, he became in
1775 physician to American troops in the expedition against Quebec. In 1778 he
married Elizabeth Arnold of Cranston, Rhode Island, and settled permanently in
Newport two years later. There he became the town's leading physician, and the
artist Samuel King was among his patients.

 Here we find King depicting his physician in the three-quarter-length pose so
popular during the late eighteenth century. That he was well acquainted with the
academic conventions utilized by his urban contemporaries is proved by the
traditional devices with which he surrounded his subject. In a comparable portrait
of the learned Reverend Ezra Stiles, King inserted several obscure personal symbols
regarding which Stiles slyly observed in his Diary: "These Emblems are more
descriptive of my Mind, than Effigies of my Face." King's bill, not rendered until
two years after Senter's death, is contained in the Albert C. and Richard W. Greene
Manuscript Collection, Rhode Island Historical Society. Under the date of Decem-
ber 4, 1793, appear charges by him for gilding the doctor's chaise, painting his
sulky, and gilding picture frames that King had presumably made. Also included
is the pertinent entry "To drawing his Portrait 11.4-."

Ref.: Frank H. Goodyear, Jr., *American Paintings in The Rhode Island Historical Society*
(Providence, 1974), pp. 24-26.

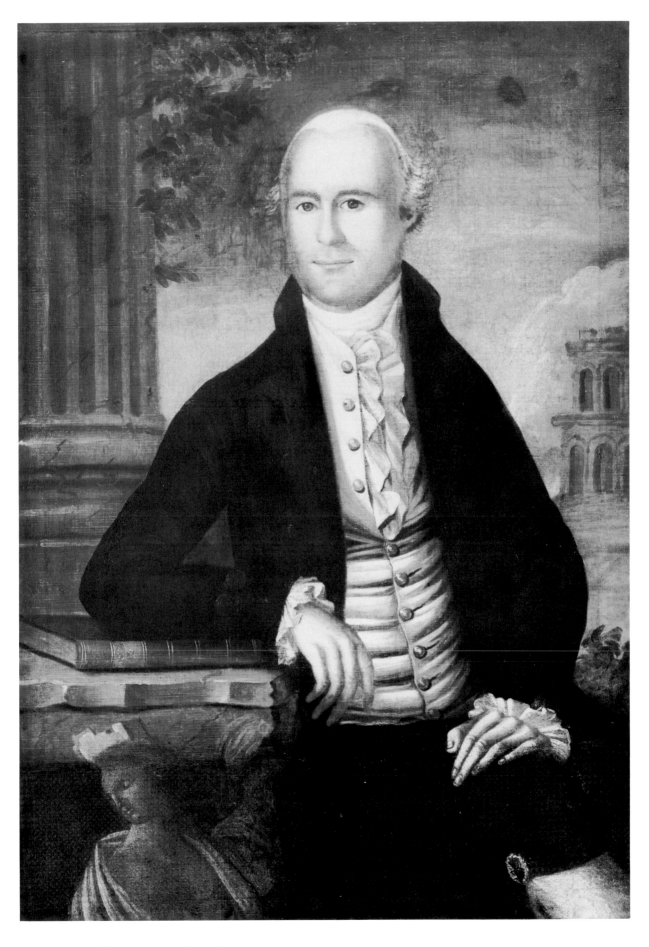

149 SAMUEL KING. *Doctor Isaac Senter*

Samuel King (1748/49-1819)

65 *Hannah Chandler*
Oil on canvas, 28 x 24 in.
Frame probably original
Deerfield Academy, Deerfield, Massachusetts

Hannah Chandler was the eldest daughter of Gardiner and Hannah (Greene) Chandler of Worcester, Massachusetts. The Chandler mansion on Main Street was described by the Reverend Timothy Dwight in his *Travels* as "one of the handsomest which I have seen in the interior of the country." Gardiner Chandler was at one time a Tory, and the British coat-of-arms, carved by his cousin Winthrop Chandler, hung above his hall fireplace. Hannah married John Williams, a Boston merchant, in 1778, and Burgoyne's Band is said to have come down from Rutland, Vermont, to play before her father's house on the night before the wedding. She died in Boston at the age of twenty-six.

 George Chandler in *The Chandler Family* refers to this painting of Hannah as "taken after her death by King," and a companion portrait of her sister Elizabeth is also attributed to him. This vivid picture illustrates several elements that have come to be associated with King's work, including the long, swanlike neck and awkward half-turned head. But the flowing drapery, decorative use of pearls, and fashionable attire such as shown here lend to many of King's subjects the appearance of sophisticated elegance with which he was familiar in pre-Revolutionary Newport.

Ref.: George Chandler, *The Chandler Family* (Worcester, 1883), pp. 231-236, 474-475.

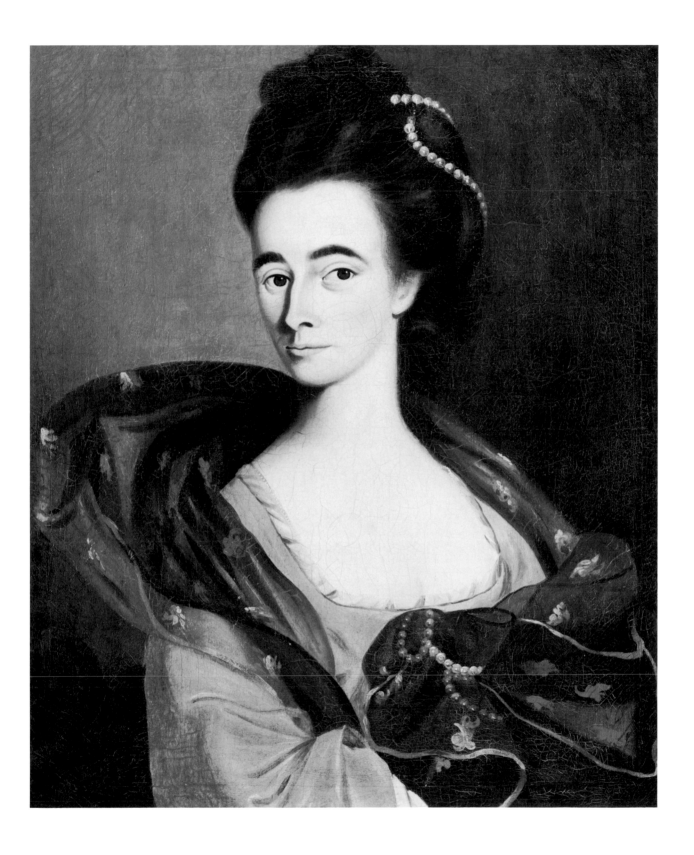

151 SAMUEL KING. *Hannah Chandler*

Reuben Moulthrop (1763-1814)

66 *The Reverend Ezra Stiles*
1794, oil on canvas, 36¼ x 25⅛ in.
Inscribed on reverse: "REV-EZRAE STILES. CILL. YAL. PRAES./
AETAT. 67./ R. Molthrop pinxit."
Yale University Art Gallery, New Haven, Connecticut
Gift of the Reverend Ezra Stiles Gannett

Ezra Stiles (1727-1795) was born in North Haven, Connecticut, son of the Rever-
end Isaac and Kezia (Taylor) Stiles. Graduating from Yale in 1746, he received his
M.A. and was licensed to preach by the New Haven Association of Ministers in
1749. He studied law and practiced for two years at the New Haven County Bar
before accepting a call to the Second Congregational Church in Newport, Rhode
Island, where he remained until 1776. In July 1778, he was installed as president of
Yale College, a position he continued to hold until his death in 1795, being recog-
nized as one of the leading scholars of his time.

Reuben Moulthrop was born in East Haven, Connecticut, son of John and
Abigail (Holt) Moulthrop. In 1793 he married Hannah Street and subsequently
painted one of his signed portraits of the Reverend Nicholas Street, his wife's
father. Moulthrop's primary occupation was modeling in wax, and from a succes-
sion of advertisements inserted in Connecticut and New York City newspapers, a
traveling exhibition of his wax figures may be traced to various localities between
1793 and 1806. In his obituary published in the *Connecticut Courant* on August
9, 1814, he was referred to as "a celebrated artist in wax-work." It is regrettable
that none of Moulthrop's many wax portrait figures appear to have survived,
especially as they included such interesting figures as Presidents Washington and
Adams, the King of France Beheaded on the Guillotine, a Barber shaving a Clergy-
man, and many other historical and topical subjects. In a 1793 *Connecticut Journal*
advertisement Moulthrop announced the painting of portraits and miniatures, and
a significant group of Connecticut pictures provides ample evidence of his ability
in the former field. Only a scant few of his portraits are signed, and the unevenness
in technique coupled with lack of a well-established style create considerable un-
certainty in arriving at firm attributions of his work. On September 25, 1794, Stiles
noted in his Literary Diary, "This aft. I sat for my Picture to Mr. Moulthrop." The
palette is subdued, but the brushwork well defined, and the sitter's compelling
gaze holds the attention of the viewer as he raises his hand in a gesture of benedic-
tion. In Stiles' inventory this portrait was valued at three pounds.

Refs.: Ralph W. Thomas, "Reuben Moulthrop, 1763-1814," *Connecticut Historical
Society Bulletin* 21, no. 4 (Oct. 1956); Samuel M. Green II, "Some Afterthoughts on the
Moulthrop Exhibition," *Connecticut Historical Society Bulletin* 22, no. 2 (April, 1957),
33-45; Josephine Setze, "Portraits of Ezra Stiles," *Bulletin of the Associates in Fine Arts at
Yale University* 23, no. 3 (Sept. 1957), 7.

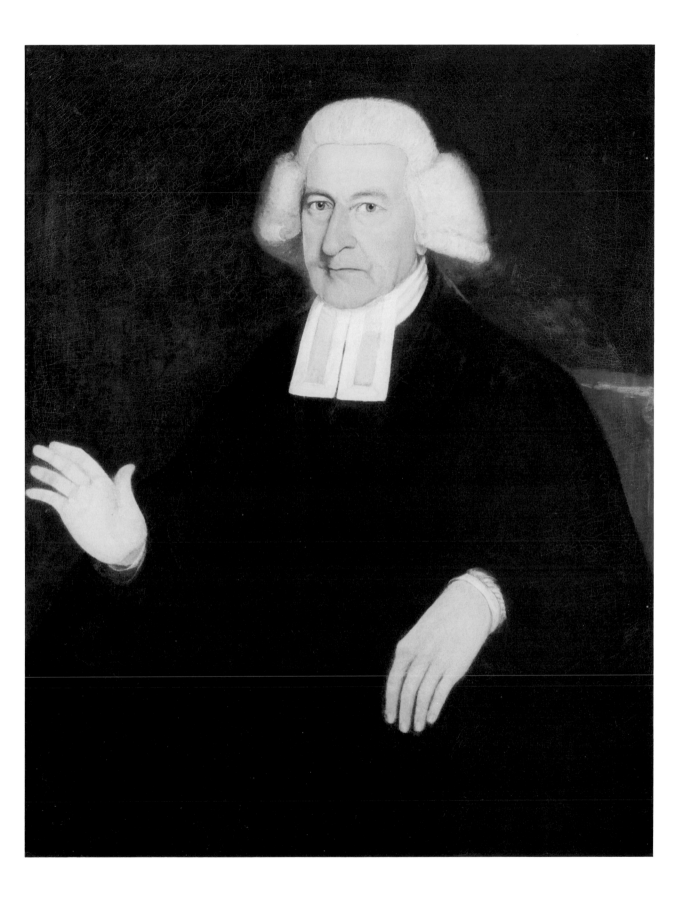

153 REUBEN MOULTHROP. *The Reverend Ezra Stiles*

Reuben Moulthrop (1763-1814)

67 *The Reverend Thomas Robbins*
Oil on canvas, 30 x 29½ in.
Signed on front at lower right: "R. Moulthrop." Inscribed on right arm of chair: "Thos: Robbins AE XXIV." Signed on back before relining: "R. MOULTHROP PINXIT. / SEPT. 1801."
Original black-painted frame with gold leaf ornaments
The Connecticut Historical Society, Hartford

Thomas Robbins (1777-1856) was born in Norfolk, Connecticut, son of the Reverend Ammi Ruhamah Robbins, and the third generation of distinguished Connecticut clergymen. He received A.B. degrees from both Yale and Williams Colleges and was licensed to preach in 1798. Thereafter he ministered to several congregations in Massachusetts and Connecticut and traveled extensively on ministerial missions by horseback, sulky, and sleigh. Robbins' most serious commitment, however, lay in assembling a significant personal library. After 1811 he added from fifty to one hundred volumes per year, setting aside twenty percent of his modest income for this purpose. In addition to books he collected Connecticut election sermons, proclamations, old newspapers, almanacs, manuscripts, and coins. He was elected recording secretary when the Connecticut Historical Society was chartered in 1825 and became its first librarian. He left to the society his four-thousand-volume library with bookcases and other furniture along with the residue of his estate as endowment to support and increase his collection.

In 1807 Robbins wrote to Moulthrop requesting him to paint portraits of his mother and father. To this suggestion the artist replied: "I should be very happy in leting you know when I could come & do them but as I have so many wax figures to make it is quite out of my power at present but if theair is an opportunity in the course of the summer I will inform you." This commission took Moulthrop five years to complete, for which he received $30.00. Thomas Robbins' own likeness, depicting him formally posed in a green-painted Windsor chair, is considered one of the artist's most skillful portraits. Robbins, already a respected clergyman at the age of twenty-five, noted in his diary for September 5, 1801, "Agreed with Mr. Moulthrop to take my portrait." Three days later he added, "Sat for Mr. Moulthrop to take my likeness." The picture has been at the Connecticut Historical Society since Robbins assumed the position of librarian in 1844.

Refs.: Thompson R. Harlow, "Thomas Robbins, Clergyman, Book Collector, and Librarian," *Papers of the Bibliographical Society of America* 61 (first quarter, 1967), pp. 1-11. "Reuben Moulthrop, 1763-1814," *Connecticut Historical Society Bulletin* 20, no. 2 (April, 1955), 44-51.

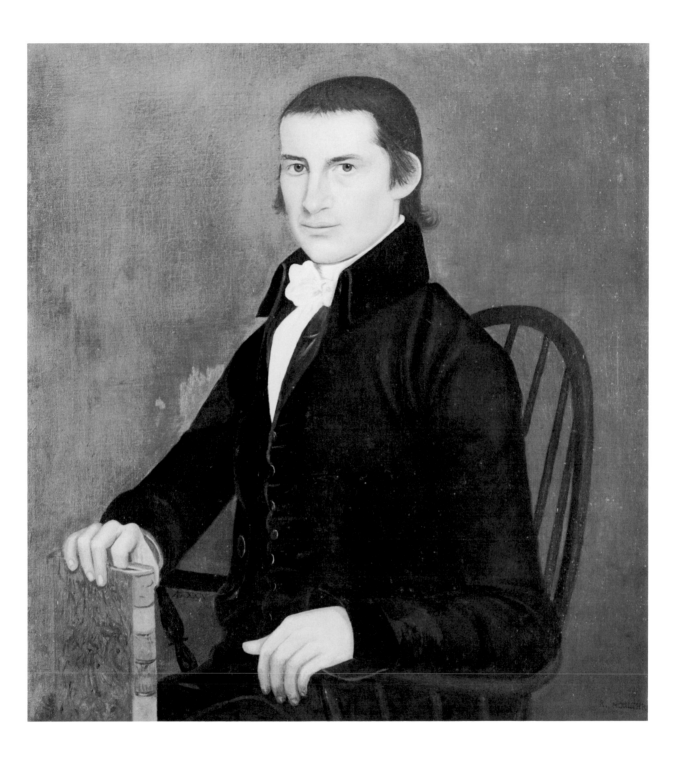

155 REUBEN MOULTHROP. *The Reverend Thomas Robbins*

Reuben Moulthrop (1763-1814)

68 *Mrs. Samuel Bishop*
Oil on canvas, 34⅛ x 29⅞ in.
Yale University Art Gallery, New Haven, Connecticut
Gift of Albert McC. Mathewson, LL.D., 1884

Mehitable (Bassett) Bishop (1728-1811) of New Haven, Connecticut, was the wife of the Reverend Samuel Bishop, who had the distinction of following Roger Sherman as second mayor of New Haven in 1786.

 This serene composition, with its almost monochromatic color scheme and careful delineation of lace, cap, and necklace, exhibits the elements typical of Moulthrop's best period of late eighteenth century portraiture. In an unusually sensitive characterization, the artist has presented Mrs. Bishop, in her mid-sixties, as the wife of a prominent Connecticut clergyman.

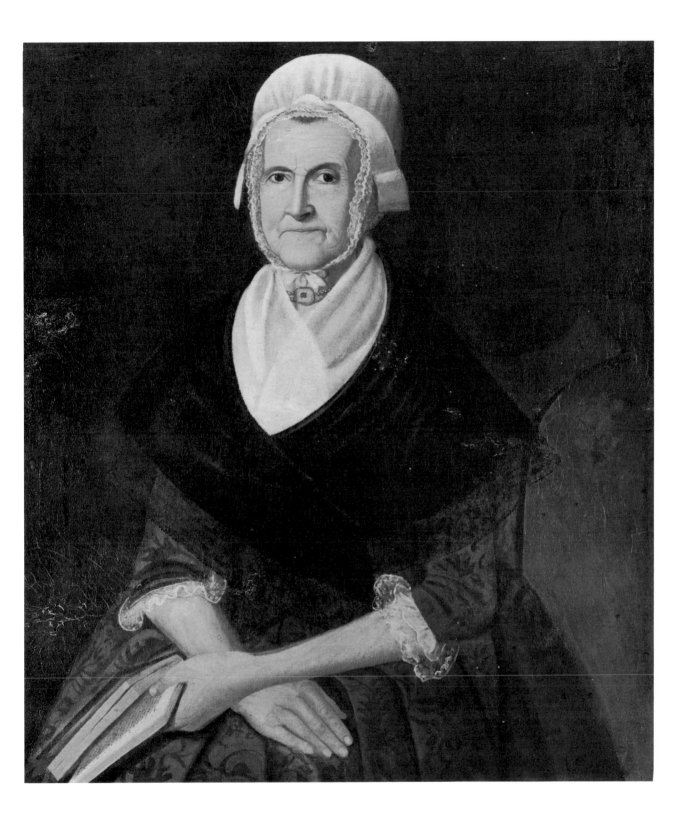

157 REUBEN MOULTHROP. *Mrs. Samuel Bishop*

Joseph Steward (1753-1822)

69 *Colonel Jeremiah Halsey*
Oil on canvas, 43¾ x 38¾ in.
The Connecticut Historical Society, Hartford

Jeremiah Halsey (1743-1829) was born in Stonington, Connecticut, and saw service in the Revolutionary War as commander of the fleet at Ticonderoga. He later served as lieutenant-colonel in the militia and in 1786 built in New London the 150-ton-vessel *Lady Strange*. In 1795 Halsey and Andrew Lloyd of Guilford gave the state of Connecticut the sum of $48,000.00, with which to complete construction of the new Hartford State House, in return for a speculative strip of land situated between Pennsylvania and New York known as "The Gore." The State House was completed in 1796 and thereafter became the Connecticut seat of government.

 Joseph Steward was born in Upton, Massachusetts, and graduated from Dartmouth College in 1780. After studying for the ministry he became seriously ill and was forced to relinquish a pastoral career. In 1789 he married Sarah Moseley of Hampton, Connecticut, where he frequently supplied the pulpit of her father's church until the latter's death in 1791. During this period Steward initiated his painting career and became an early instructor of the deaf and dumb artist John Brewster, Jr. (nos. 18-21), whose father was Hampton's foremost physician. In 1796 Steward opened a painting room in the newly completed Hartford State House and in June of the following year established his Hartford Museum in the "east upper space chamber for portrait painting and repositing therein paintings and natural curiosities." The museum soon outgrew its quarters and in 1808 removed to a new location, but its collections remained intact until at least as late as 1840. Steward continued to paint, did substitute preaching, published hymns, and made profile likenesses at the museum until his death after a long illness in 1822. In the background of Halsey's portrait Steward introduced a well defined vignette of the State House with which his sitter was so closely involved. This is the earliest known view of the building as originally constructed, of stone from the Portland quarries topped by a second story of brick. On May 19, 1796, twelve chairs of Hepplewhite design, made by Lemuel Adams of Hartford for the senate chamber, were billed to Halsey in the amount of 105 pounds, 6 shillings, and he is shown sitting in one of them. Halsey also supplied the room with "4 Best ink potts" similar, perhaps, to the one that appears in his portrait.

 Joseph Steward was one of New England's most competent provincial artists, and many of his large canvases are rich in color and detail. In addition to achieving convincing likenesses of his subjects, he introduced into the paintings furnishings typical of the period, which add greatly to one's visual impressions of late eighteenth century interiors. This picture came to the Connecticut Historical Society from the old Hartford Museum, where it is known to have been exhibited together with other "curiosities" designed for "the increase of rational and instructive amusement."

Refs.: Newton C. Brainard, *The Hartford State House of 1796* (Hartford: the Connecticut Historical Society, 1964); "Joseph Steward and the Hartford Museum," *Connecticut Historical Society Bulletin* 18, nos. 1-2 (Jan.-April, 1953).

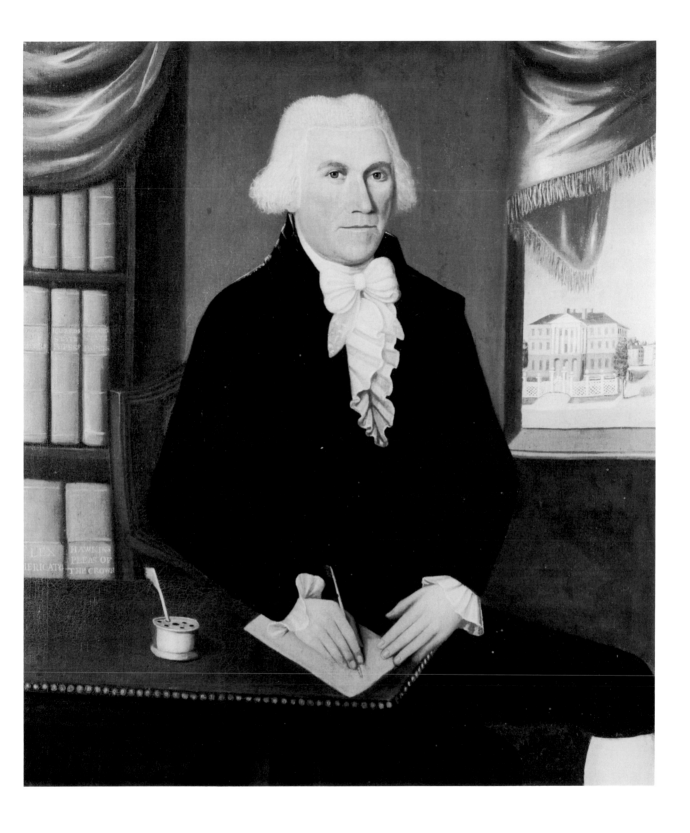

159 JOSEPH STEWARD. *Colonel Jeremiah Halsey*

Joseph Steward (1753-1822)

70

John Phillips
1794-1796, oil on canvas, 78 x 68 in.
Dartmouth College Galleries and Collections,
Hanover, New Hampshire

John Phillips (1719-1795) was the son of the Reverend Samuel and Hannah (White) Phillips of Andover, Massachusetts. A graduate of Harvard College in 1735, he settled in Exeter, New Hampshire, to teach school at least as early as 1740. There he also carried on a country store, married a well-to-do widow, Sarah (Emery) Gilman, and accumulated considerable wealth partly through real estate speculation. He made liberal gifts to Dartmouth College, of which he became a trustee in 1773. He subsequently founded both Phillips Academy, Andover, and Phillips Exeter Academy, serving terms as president of both boards of trustees and contributing substantial financial support. Phillips is said to have been austere of temperament, puritanical of spirit, frugal, conscientious, and religious.

On August 28, 1793, the trustees of Dartmouth College voted to commission Joseph Steward, a graduate in 1780, "to take a whole length portraiture of the honorable John Phillips, LLD to be deposited in one of the public chambers of this University at the expence of this board; said Steward having agreed to do it at the price of twelve guineas including his expences of travelling to and from Exeter for the purpose." The question has arisen as to whether the picture's paneled interior, floor covering, and stenciled walls represented the Phillips home on Water Street in Exeter. (The house was destroyed by fire on the night of December 2, 1860.)

In a letter dated November 5, 1793, Steward postponed starting the portrait until the following February 1794, and the unstretched canvas was not sent from Hartford to Dartmouth College until the fall of 1796. During most of those years Steward was apparently living at the home of his father-in-law in Hampton, Connecticut, where three of his children were baptised in 1790, 1792, and 1796. It seems probable, therefore, that a preliminary likeness of Phillips was painted in Exeter as agreed in 1794, but that the full-length figure and surroundings were executed in the artist's home in Hampton. This supposition is strengthened by the existence of a duplicate bust portrait of Phillips that was apparently retained by Steward and is known to have been exhibited in his Hartford Museum. It is now owned by the Connecticut Historical Society.

Ref.: Manuscript collections in Baker Memorial Library, Dartmouth College, Hanover, New Hampshire.

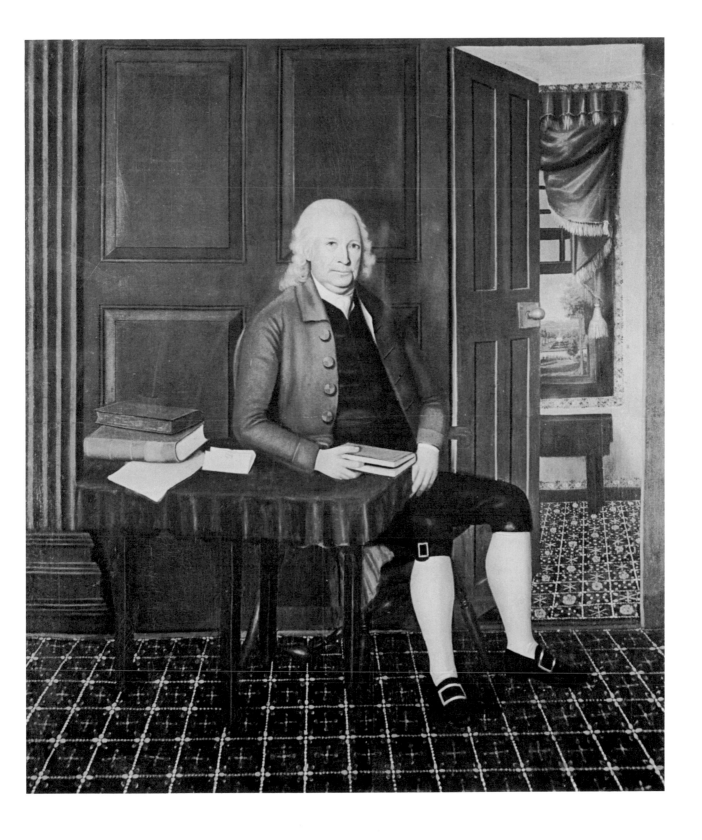

161 JOSEPH STEWARD. *John Phillips*

Joseph Steward (1753-1822)

71 *The Reverend Eleazer Wheelock*
1794-1796, oil on canvas, 79 x 70½ in.
Dartmouth College Galleries and Collections,
Hanover, New Hampshire

Eleazer Wheelock (1711-1779) was born in Windham, Connecticut, the son of
Ralph and Ruth (Huntington) Wheelock. Two years after graduation from Yale
College in 1733 he was installed as pastor of the Second (North) Church in
Lebanon. In addition to being a minister, itinerant revivalist, and farmer, he also
began to instruct Indian students and to formulate definite plans for their education
and conversion. By 1765 he had received twenty-nine boys and ten girls, all sup-
ported by charity. In order to expand the educational program, funds were raised
in Great Britain by one of Wheelock's Indian graduates and a charter was granted
which enabled the school to move to Hanover, New Hampshire, where it was in-
corporated as Dartmouth College in 1769. Wheelock continued as president for
the ensuing ten years, seeing the college through the turmoil of the Revolution
when support from overseas was largely withdrawn. Wheelock's son, John, fol-
lowed as the second president after the former's death in 1779.

 In 1793 when the Dartmouth trustees commissioned the portrait of John Phillips,
they also requested Joseph Steward to paint a full-length portrait of the late Presi-
dent Wheelock, and these two pictures, delivered to Dartmouth in the fall of 1796,
are believed to be the earliest documented examples of Steward's work. Yet his
professional reputation must have already been established or he would hardly
have been entrusted with such important commissions. Comparison of the interior
settings suggests that both the Wheelock and Phillips pictures were painted in
virtually the same surroundings, probably Steward's own home. A reference that
seems to confirm this fact is found in an early nineteenth century statement by
Professor I. L. Kingsley of Yale, who wrote: "I saw that [Wheelock's portrait]
painted at Hampton, Connecticut, when I was sitting for College with Parson
Ludovicus Weld who sat for the lower half of the picture." Steward could have
painted the features from memory, as he was an undergraduate at Dartmouth when
Wheelock died in 1779. As in the case of John Phillips, the artist also painted a half-
length study of Wheelock, which was exhibited in his Hartford Museum and came
into possession of the Connecticut Historical Society as early as June 1844.

Ref.: "Joseph Steward and the Hartford Museum," *Connecticut Historical Society
Bulletin* 18, nos. 1-2 (Jan.-April, 1953), 3-6.

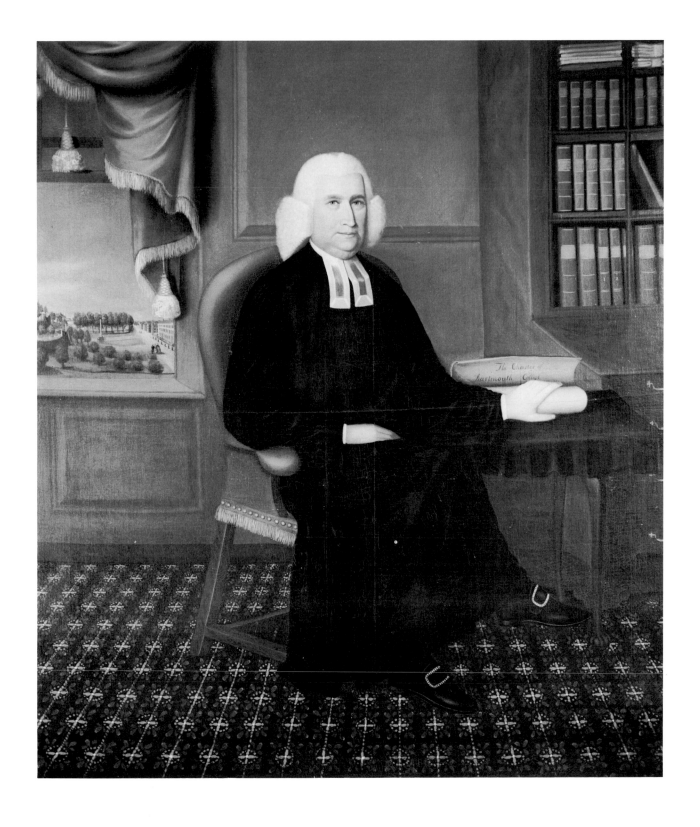

163 JOSEPH STEWARD. *The Reverend Eleazer Wheelock*

John Trumbull (1756-1843)

72 *Mr. and Mrs. Jonathan Trumbull, Jr., and Their Daughter Faith*
1777, oil on canvas, 38 x 48 in.
Yale University Art Gallery, New Haven, Connecticut

Jonathan Trumbull, Jr. (1740-1809) was the second son of Governor Trumbull of Connecticut and his wife Faith Robinson. A dominant figure in public life during and after the Revolution, Jonathan, Jr., held among other important offices the position of military secretary to General Washington from 1781 to 1783. A staunch Federalist, he was Speaker of the House of Representatives, a United States senator from Connecticut, and from 1797 to 1809, governor of Connecticut. He graduated from Harvard College in the class of 1759, and when his younger brother John was admitted to the college in February of 1772, Jonathan, Jr., paid his tuition fee of £24.

Beside her husband sits Eunice (Backus) Trumbull (1749-1826) with their eldest daughter, Faith (1769-1846), who was to marry Daniel Wadsworth, founder of the Wadsworth Atheneum. In John Trumbull's "Account of Paintings" he refers to this picture as no. 27 under the heading of "Lebanon": "Portraits of my brother Jonathan, his wife & daughter, in one piece, 4 feet by 3.2 begun April 21st 1777, paper £42."

John Trumbull was born in Lebanon, Connecticut, the younger brother of Jonathan, Jr., the subject of this painting. As a child he exhibited an interest in drawing with which his father was not entirely in sympathy. Entering Harvard College in the middle of his junior year, he graduated in 1773, the youngest member of his class. He soon returned to Lebanon to teach and to paint classical subjects. After serving in the Continental Army from 1775 to 1777, he returned to Boston and took up residence in John Smibert's old painting rooms. There he copied Smibert's copies of old masters as there were no artists left in Boston whom he felt were qualified to teach him. During his youthful years, before formal study abroad, Trumbull painted the lively portraits of his family and friends that have earned him recognition as one of New England's foremost provincial artists.

Carrying assurances that he would be welcome to pursue his art in England, Trumbull set sail for Paris and London in the spring of 1780 to study in the studio of Benjamin West. Son of the Governor of Connecticut and member of a family of means and position, he was the first American college graduate to become a professional portrait painter. For some time he lived intermittently in London, and the distinguished American portraits and historical canvases of his middle and later years illustrate the development in his style and reflect the academic influence of West and the artist's own European experience. He requested to be interred beneath his pictures in a stone vault below the Trumbull Art Gallery on the old Yale campus, which he and his friend Ithiel Town had designed. The exhibition of his collection was opened in 1832, and Trumbull hoped the gallery would remain his personal monument. The building, however, was finally demolished in 1901, but following his wishes, his remains and those of his wife were re-interred beneath the present Yale University Art Gallery, where his pictures now hang.

Refs.: Irma B. Jaffe, *John Trumbull, Patriot-Artist of the American Revolution* (Boston: New York Graphic Society, 1975), pp. 287, 313, 314; Theodore Sizer, ed., *The Autobiography of Colonel John Trumbull* (New Haven: Yale University Press, 1953), pp. 1-57, 378-382.

165 JOHN TRUMBULL. *Mr. and Mrs. Jonathan Trumbull, Jr., and Their Daughter Faith*

John Trumbull (1756-1843)

73 *Portrait of the Artist's Parents*
Oil on canvas, 38 x 51½ in.
Signed on center front: "I:T. 1775." Inscribed on reverse: "Jonathan
Trumbull Senr AE 64/ Govr of Connt/ Faith Robinson his Wife AE
56/ Pinxt John Trumbull Filius AE 18/Lebanon 1774/ The original
Brother Jonathan."
Black and gold scoop-molded frame probably original
The Connecticut Historical Society, Hartford

Jonathan Trumbull (1710-1785) was born in Lebanon, Connecticut, graduated
from Harvard College in 1727, and married Faith Robinson (1718-1780) of Dux-
bury, Massachusetts, in 1735. He abandoned theological studies to pursue a busi-
ness career and also became influential in state political and military circles. He was
a judge of Windham County Court from 1746 to 1749 and became governor of
Connecticut in 1769, in which office he served with distinction until his resignation
in 1784. He died one year later, his wife having predeceased him in 1780.

 This striking, trompe l'oeil study of John Trumbull's parents was painted in
1775, two years after the artist's graduation from Harvard, and represents Jona-
than and Faith Trumbull as depicted by their son's as yet untrained hand. An in-
teresting illustration of the use of engraved sources, this unique composition is
described in Trumbull's *Autobiography* in the following words: "Portraits of my
father and mother, heads in oval spaces, surrounded by ornamental work, from
Houbraken's heads— Justice and Piety &c." The reference is to the Dutch engraver
Jacob Houbraken (1698-1780).

167 JOHN TRUMBULL. *Portrait of the Artist's Parents*

John Trumbull (1756-1843)

74 *Major-General Jabez Huntington*
1777, oil on canvas, 47½ x 37½ in.
Connecticut State Library, Hartford

Jabez Huntington (1719-1786) was born in Norwich, Connecticut, the son of Captain Joshua and Hannah (Perkins) Huntington. After graduating from Yale College in 1741, he became a merchant in Norwich. On his father's death he took over the latter's mercantile business and owned many vessels engaged in foreign trade at the beginning of the Revolution. He participated actively in public affairs and in 1776 was appointed major-general in the Connecticut militia. From this time on he was in constant touch with many prominent leaders such as Washington, Lafayette, Thomas Hancock and Governor Trumbull until his retirement from active service in 1779. His son, General Jedidiah Huntington, married Faith Trumbull, the artist's sister. It was she who had been John Trumbull's childhood preceptor in drawing.

In Trumbull's *Autobiography* a list of drawings and pictures "executed before my first voyage to Europe, and before I had received any instruction other than was obtained from books" contained the following reference: "Portrait of Maj. Gen. Jabez Huntington of the militia, whole length, half size of life, 1777." The artist's list, prepared in 1789, adds this information about his execution of the picture: "begun 16th April, 1777, at the Age of 21. was paid for it (paper)—fifteen Gns." The military encampment in the background appears to symbolize Huntington's involvement with military affairs, but the dramatic pose was inspired by a seventeenth century print by Salvator Rosa, which, in turn, was based on a statue of Augustus Caesar in the Vatican Museum. The face, however, with its sharply chiseled features, exhibits the characteristics of Trumbull's early style.

Ref.: Theodore Sizer, "John Trumbull, Colonial Limner," *Art in America* 37, no. 4 (Oct. 1949), 197.

See also colorplate, p. 15.